MY MOMENT

CLARE AKUMU JANN ARDEN ROSANNA ARQUETTE BROOKE BALDWIN SOPHIA BANKS
SHOSHANA BEAN CELIA BELL LAUREN BLITZER JEAN BRADEN
SAMANTHA BRENNER CAROL BURNETT YVETTE BURTON EMILY CAIN
MARY-MITCHELL CAMPBELL BRANDI CARLILE ROSANNE CASH
HAVANA CHAPMAN-EDWARDS RABIA CHAUDRY KRISTIN CHENOWETH
SHERYL CHINOWTH S.E. CUPP MANDANA DAYANI SHARON DIAMOND
TRACY EDWARDS CYNTHIA ERIVO JENNIFER ESPOSITO FORTUNE FEIMSTER
BEANIE FELDSTEIN RENÉE FLEMING AMANDA FREITAG JILL FRITZO

MY MOMENT
106 WOMEN ON FIGHTING FOR THEMSELVES
COLLECTED BY KRISTIN CHENOWETH, KATHY NAJIMY, LINDA PERRY, CHELY WRIGHT, AND LAUREN BLITZER

DAISY FUENTES JOANNA GAINES AMIKA GEORGE ANNA GIFTY OPOKU-AGYEMAN
RIYA GOEL BARBARA GOTHARD LEELEE GROOME CHELSEA HANDLER
MEENA HARRIS YASMEEN HASSAN STEPHANIE HOPSON MICHELLE HURD
CHRISSIE HYNDE FELISA IHLY HETAL JANI SHANNON JUBY
BILLIE JEAN KING LYNZY LAB RICKI LAKE LIZ LAMBERT MIYA LAO
CYNDI LAUPER CARMEN LoBUE ZOSIA MAMET TIFFANY MANN
MALLORY MANNING ARETHA MARBLEY ORLY MARLEY JUDY MAYFIELD
REBA McENTIRE DEBRA MESSING MONA MORIYA JANELLE MURREN
KATHY NAJIMY SHAKINA NAYFACK SOLEDAD O'BRIEN ROSIE O'DONNELL
KELLI O'HARA PRIYANKA PATIL ALICE PEACOCK FERIAL PEARSON PEPPERMINT
MICHAELA PEREIRA LINDA PERRY MELISSA PETERMAN TONYA PINKINS
PAOLA RAMOS KIMBERLY REED MJ RODRIGUEZ ALLISON RUSSELL
EMILY SALIERS JUDY SEALE ALICIA SILVERSTONE MAGGIE SMITH KYLE SMITLEY
MEG STALTER GLORIA STEINEM BECCA STEVENS ALI STROKER SUCH
TINA TCHEN MARLO THOMAS STACEY TOPKIN OLIVIA TROYE MARY L. TRUMP
AISHA TYLER JENNA USHKOWITZ JENNIFER VALKANA LENA WAITHE DORRIS WALKER-TAYLOR
ADRIENNE WARREN SHANNON WATTS MAYA WILEY CHELY WRIGHT STEPHANIE YEBOAH

GALLERY BOOKS
New York London Toronto Sydney New Delhi

G

Gallery Books
An Imprint of Simon & Schuster, Inc.
1230 Avenue of the Americas
New York, NY 10020

First Gallery Books hardcover edition May 2022

GALLERY BOOKS and colophon are registered trademarks of Simon & Schuster, Inc.

For information about special discounts for bulk purchases, please contact Simon & Schuster Special Sales at 1-866-506-1949 or business@simonandschuster.com.

The Simon & Schuster Speakers Bureau can bring authors to your live event. For more information or to book an event, contact the Simon & Schuster Speakers Bureau at 1-866-248-3049 or visit our website at www.simonspeakers.com.

Interior design by Davina Mock-Maniscalco

Manufactured in the United States of America

10 9 8 7 6 5 4 3 2 1

Library of Congress Control Number: 2021952314

ISBN 978-1-9821-6092-0
ISBN 978-1-9821-6093-7 (ebook)

For the girls and women who have gone before us—each of them laying down their single pebble to pave the road upon which we all walk

With gratitude,
Kristin, Kathy, Linda, Chely, and Lauren

CONTENTS

DEAR READER,

It wasn't an *a-ha!* moment that led us to ask more than one hundred women the same exact question over the course of two years. It was a culmination of events throughout each of our lives that became unearthed when we saw the heroic Dr. Christine Blasey Ford stand in the Senate Chambers. With her right hand raised, she swore to tell the truth—the whole truth. Her voice shaking, she recalled and relived sexual assault committed by a man about to serve a lifetime appointment to the highest court in the land. We watched members of the committee question HER memory, HER interpretation of the events, HER ethics. He was innocent until proven guilty, in this case, with the understanding that proof would never be beyond a reasonable doubt. Her display of grace and strength was a master class.

The voice of one woman, who came to represent so many of us, was mocked, disregarded, and silenced. Craving sisterhood, we took to text chains with best friends, relatives, colleagues, and each other. Stories began to bubble up, from inappropriate encounters and incidents normalized as a sign of the times to stories of workplace injustices, schoolyard bullying, physical and sexual abuse.

We, five friends who have lifted each other up for years, took an inventory of all the stories that we'd accumulated from the women in our lives. We thought that if we were able to share these accounts more widely we could not only inspire and give hope but quite possibly save a life. We started posing this question to women of all different backgrounds and ages:

"What was the moment in your life when you realized you were ready to fight for yourself?"

It was simple, to the point, and capable of evoking the most powerful and poignant responses.

Each answer was unique, and yet common themes emerged around coming out, racism, body shaming, sexism, motherhood, activism, sobriety, and more. The women in the pages of this book give an intimate look at the private moments that typically get overlooked but are often life-changing.

In early 2020, our original plan was to photograph each person professionally. Then Covid hit. Editorialized, consistent black-and-white portraits all shot by the same photographer were no longer an option. But women can turn any problem into an even better outcome. With help from Sony Electronics, we sent most of the contributors a Sony DSC professional camera and asked that they have a woman or girl important to them take their photo. The results were breathtaking. Beautiful portraits by mothers, daughters, best friends of forty years, and even a few self-portraits filled our inboxes.

My Moment was a true labor of love. We are honored to share these incredible stories with you. We hope you will use them as a guide and draw inspiration and comfort from the words of these women, many of whom have changed the course of history and some who will be the next to do so.

And remember, we are in this together—you're not alone.

Love,
Kristin, Kathy, Linda, Chely, and Lauren

P.S. What was *YOUR* moment?

"WHAT WAS THE MOMENT **IN YOUR LIFE** WHEN YOU REALIZED **YOU WERE READY** TO FIGHT FOR YOURSELF?"

CHRISSIE HYNDE

Singer, Songwriter, and Musician (Founding Member of the Pretenders)

Born 1951 in Akron, OH

The moment I was born.

CLARE AKUMU

College Student and Activist

Born 1999 in Kampala, Uganda

At the age of thirteen, I was stricken with a serious illness, and one year later, I could no longer walk, run, or even stand. Still to this day, my doctors have not been able to define exactly what happened to my body or even why, but whatever it was, my life was changed forever.

In Uganda, girls' education is not prioritized. Just two out of every ten girls graduate from high school. Many things contribute to this statistic: lack of resources, long-standing social norms that set low expectations for girls, high teenage pregnancy rates, and an inherent cultural standard that values boys over girls.

I happened to be one of the few girls in Uganda who attended school, but because of the complications from my illness, I had to stop going to school for a year. It was devastating.

I was in excruciating pain every minute of every day, especially my feet. I was also suffering emotionally. I vividly remember saying to myself, "Clare, you are in a terrible state." I was overwhelmed with fear about how I would live with my new reality.

The illness continued to wreak havoc on me and I lost hearing in my right ear. As the saying goes, when it rains, it pours. I cried myself to sleep for months. I wallowed in some self-pity, but mostly, I had a lot of anger toward God. Every time I prayed, I asked just one question, "God, how could you?" Suicide crossed my mind more than it should have. I slipped into depression and began taking antidepressants, which likely saved my life.

I am the youngest of five children and because I have supportive and helpful parents and siblings, I was able to focus on getting better. After a long, hard year of phys-

ical therapy, I was able to learn how to walk again, which meant that I could return to school. I was overjoyed that I could attend school despite the pain that I was still going through. It was not easy, but I had my heart set on being back in the classroom.

Before I got sick, I'd never been a shy or timid girl, but the new version of me was uncertain. The illness had shattered my self-confidence, and when I returned to school, I quickly learned that I was the topic of negative comments from my classmates. I overheard some of the things they said and their words stayed with me. There was one statement that I will never erase from my mind—I can still hear it. "She walks like a chicken."

How could someone say something so insensitive? I had worked so hard to walk again. I felt hurt and angry and disrespected. I struggled and failed to hold back the tears, but something happened as I cried over those insults. Through my tears, something clicked inside of me. The confident girl I'd always been, before I got sick, came roaring back with a fury. I made up my mind that if I was going to be the subject of their conversations, I would be a worthy subject. I would give them something to talk about.

The "chicken" mockery was my turning point, my moment, and I have *never* looked back. Yes, there are times when my disabilities bring great sadness, but my tenacity cannot be shaken. When leadership opportunities came my way, I jumped for them like a wild animal. I ran for class government positions and of course, I won with the majority votes. I graduated high school at the top of my class.

I also became an advocate for the silent majority who have not yet found their courage. I am a peer educator with Girl Up Initiative Uganda, an organization that supports young girls and women to thrive and lead, and that role has given me a space to grow and discover myself. Now I am awake to the truth that there's so much potential in me that I can use to impact the lives of many women and girls with disabilities and also those without.

I'm now in college, pursuing my bachelor's degree in business administration, and I'm more confident than ever before. My family and friends are great cheerleaders, supporting me every step of the way. Each and every day, I fall in love with who I am.

SAMANTHA BRENNER

Entrepreneur

Born 1975 in Tulsa, OK

Although I didn't recognize it as a defining moment when it occurred, my "moment" happened when I was eleven years old and in middle school in Tulsa, Oklahoma. For whatever reason, I drew attention and criticism from a boy in my class who decided it would be fun to make me the object of his ridicule and bullying. No need to use his real name (it still makes me grimace), so I'll just call him Tom Foolery (because that makes me smirk). At first, I didn't pay much attention to the name-calling and jeers, and often returned Tom's petty insults with a few zingers in tit-for-tat fashion. His bullying wasn't the threatening kind; just the menacing kind and eventually escalated from verbal jabs. Really original stuff, like "accidentally" bumping into me, forcing me to crash aggressively against a bank of lockers, or "coincidentally" jutting a foot out as I rounded a corner, sending me (and my books) flying asunder to the floor. This was in the '80s, when teachers and principals would leniently dismiss such behavior with a slap on the wrist or a warning because "boys will be boys."

But one afternoon, as I sat down in my chair at my word processor to begin a typing test (requiring me to type a certain number of words per minute), I felt a burning sensation on the backs of my thighs. Reacting to my surprise and obvious discomfort, Tom couldn't contain his laughter, and through his snorts squealed, "Get used to it—that's where girls belong, glued to a typewriter!" Not wanting to attract the attention of the teacher or disrupt the entire class that was poised with their hands hovering over their keyboards, I attempted to discreetly readjust in my chair. When that proved unsuccessful, I tried to stand up but couldn't, and commotion ensued. Tom had literally glued me to my chair—superglued me, to be

exact. This time, the infraction earned him more than just a slap on the wrist. The classroom was emptied, and he got suspended before the female teacher who was summoned to help free me from my chair had even arrived with scissors and some kind of solution that I can still smell to this day. Thankfully, I was wearing gym

shorts under my plaid uniform skirt (as most of us did back then), so I was slightly less humiliated as the extraction slowly unfolded.

That evening, my mother could see the embarrassment on my face and the insecurity taking hold within me as I considered the words Tom had said to me. Not on her watch. She reminded me that he was just a bully and that his insinuation was utterly absurd and insisted that I *never* consider myself lesser than a boy or man, or anyone else for that matter. I will always remember that day, not so much as the day Tom Foolery glued me to my chair and essentially told me I was destined to be a secretary simply because I was a girl, but as the day my mother unglued any and all gender stereotypes that might have crept into my subconscious, which could have ultimately limited my possibilities purely on the basis of my sex. It was the day I learned to always stand up for myself and others (even if I literally couldn't).

After all that, as much as I wanted to push Tom into a locker or trip him or glue him to a chair, I didn't. I did, however, accidentally strike a ball a little too high at him during a game of kickball in gym class and it happened to make contact with his nose. My aim was never and has never since been that good, so his nose truly was an unintended (and lucky) target. I did apologize as tears streamed down his face. Typing class was the next period, so I took joy in pointing out that at least he wasn't glued to the floor. Whenever I used to think about him crying on the gymnasium floor, I'd shrug my shoulders, grant myself leniency for the inadvertent retaliation and quip, "Girls will be girls." I know it's not what Michelle Obama meant when she uttered her now-famous motto about negative influences, "When they go low, we go high," but the irony does make me laugh.

MIYA LAO

Student

Born 2007 in Los Angeles, CA

People have always made fun of my height. In fourth grade, it bothered me, but my friends would always take care of me and tell me that I was perfect and I would laugh and joke around with them all the time and just have a blast. Toward the end of fifth grade, I grew tired of three people in particular calling me names. They were always mean to me and I tried to find out the reason why. After I graduated elementary school, I was super excited to become a sixth grader. I decided to completely ignore the name-calling and turned it around to think it was silly. Silly that people think it's entertaining to make fun of people's size or anything else they can think to pick on. That was my moment, realizing these people didn't know me and didn't care about me. I didn't need to give them any more of my attention, because they weren't my friends.

I've always loved to play softball and people say I'm really good at it. It makes me feel good about myself because they also say that my size makes me ten times better. They say I'm especially good at running since I'm so small. Also, my strike zone is small so pitchers couldn't strike me out and I thought that those were also good qualities. If people called me names, I would come back at them. Not in a mean way but I would say something like, "Hey! Why are you picking on someone who never did anything to you?!" They would laugh and say, "Oh, maybe it's because it's easy to pick on the short kids." Seriously? That's what they thought? That made me think, *Oh, because I'm shorter they can take my stuff and wave it above their heads.* Idiots.

Softball helped me make tons of friends outside of school. When my school friends would fight or were mad at me or at each other or have drama with other

people whom I had no clue about, I would go to softball practice and hang out with my softball friends. Of course I would always pay attention during practice, but at breaks we would talk, laugh, and have a good time. My softball friends wouldn't care if I messed up or get mad if I talked too much. There was no judgment—it was all about the game and how we could help each other win. They were always there for me.

Don't feel beaten down if someone is messing with you. Fight back in a nice way. If they laugh at you for trying to fight back, just walk away and ignore them. You don't need them and they can't tell you who you are or aren't. You're perfect the way you are. Always feel positive about yourself, and when you don't, don't take it out on other people, because that will make things worse. Stay calm and happy and you'll be a happy person, even when life tries to get in the way of that. You're the one who decides how you're going to feel about yourself.

LEELEE GROOME

Executive Producer

Born 1965 in Bryn Mawr, PA

As a ten-year-old, I vacuum-packed *boy* into the word *tomboy*. To me, being a boy meant being free. Unencumbered. It seemed that with nominal punitive repercussions, boys could fly things, hit things, get dirty, spit, whistle, and fart, and I wanted every bit of it.

It was June. It was hot and I was bored. Barefoot, shirtless, and in a pair of cut-offs, I grabbed two pennies off my dresser and walked toward the train tracks. An easy route. Bang a right at the gas station, shuffle behind the dumpsters, and fifteen cartwheels later—the tracks. At ten years old, watching a train flatten a penny was much better than waiting in the kitchen for a Shrinky Dink to bake.

That day, when I banged the right at the gas station, my eye caught a five-dollar bill wrapped around a cigarette butt. Like a fumbled football, I tried to smother it. But by the narrow margin of a train-flattened penny, a large steel-toed boot beat me to it.

My eyes scanned up the leg in the boot and then across an oil-stained shirt. RICK. MECHANIC. Through the blister of sun, we locked eyes and he snapped the bill between two fingers. "I'll give it to you if you pump some gas for me," Rick said. But what I heard was, *Today is the day all of your dreams come true.* I nodded. "Right on," Rick said. "You pump, I play my guitar, and if nobody dies, it's yours. Oh, and grab a dipstick from the bucket. If you don't see a rag, use your shorts, I guess." At that moment, I fit perfectly inside my skin.

As the sun set, Rick and I struck a deal. Three days a week, Rick would practice his guitar and I would pump his gas. A buck an hour. In two months, I would be able to buy that striped banana seat for my Schwinn and a guitar tuner for Rick. Aces.

On Sunday, August 22, 1976, my mom announced that we were going to a baptism. "Lee, I am not going to argue. You will wear your Mary Janes and the blue dress with the belt." I agreed not to argue if my mom agreed that we'd be home in time for me to change into jeans and sneakers and be at the gas station by 12:00 p.m. With a well-versed roll of the eyes, she acquiesced.

It was 12:12 p.m. when we left the church. I was frantic.

As my mom drifted into the gas station, I punched open the car door and me, my dress, and my Mary Janes were on the move while the car was still rolling to a stop. I heard my mom yell, "Goddammit, nothing is *that* important!" I remember a burn in my rib. *She has no idea who I am.*

Rick was at the pump. Sprinting, I called to him, "Rick, Rick! Sorry I'm late. . . . This church thing . . . my mom promised . . . but . . . the baby . . ." Completely out of breath, I loosened the belt around my dress and bent over. "His little hat wouldn't stay on. . . . Anyway, I'm sorry, man. I got this . . . it's guitar time."

My panting slowed and I uncurled upright only to see Rick's face go from being Rick to being a face I only recognized on my mom when I would pretend to chew

tobacco. He took four steps backward and shoved both hands into his front pockets. He locked in on the Mary Janes, inched slowly to the dress, and then paused at my face, his eyes uneven. "You're a girl?"

It all lasted less than sixty seconds.

"Yeah?" I said.

"You lied to me," he said.

"I did not," I said.

"You pretended to be a boy," he said.

"I did not," I said.

"Then are you pretending to be a girl right now?" he asked.

I think so, I never said.

"Well, you're either a dyke or a fag, and both make me sick. Get the raincoat you left here and get the hell outta my sight," he said.

My heart splintered. I wanted to drain the gas from each pump and light a match. I wanted to rip off my dress and go lie on the tracks—and just wait. Wait for the train to flatten me like a nothing penny.

I didn't lie.

I walked to the garage to retrieve my raincoat, the belt of my dress dragging behind me. I could feel a bubble on my heel fill with liquid. I leaned on Rick's chair, untied the laces, and stepped out of my shoes. I started my walk home, leaving the stiff, ugly Mary Janes next to Rick's guitar.

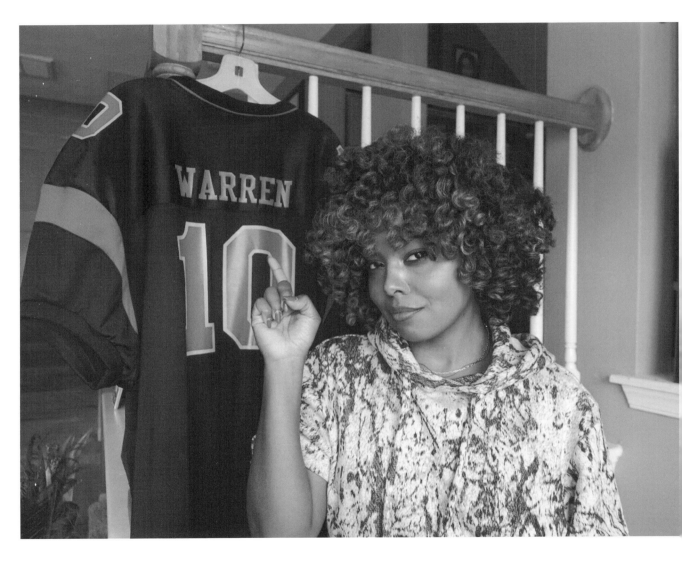

ADRIENNE WARREN

Actor, Singer, and Dancer

Born 1987 in Hampton Roads, VA

I may have been around eight or nine when I was a guard on an all-boys basketball team at my local gym. It was such a special time for me, because it was the first formal team I was on and my teammates never made me feel like I didn't belong. I was encouraged and included because of my talent.

However, this wasn't always the case during games with other teams.

I specifically remember bringing the ball down the court, setting up a play, when the defensive player covering me looked at me and said, "Why don't you go and play with your Barbies?"

This infuriated me for many reasons. I hated Barbie and was always more interested in her accessories. Also, the player was insinuating I didn't belong on that court because I was a girl, which at the moment I felt was ridiculous. Wasn't I playing just as hard as all the boys? Wasn't I an asset to my team?

In an instant, I felt fire through my veins and knew I had to prove to him as well as myself that I was exactly where I needed to be. I never grew up in an environment where my ambitions were limited because of my sex or race. It wasn't until I ventured out into the world that I began to feel those constraints infiltrate my optimism and even my joy.

The moment that young boy told me I didn't belong was the moment I decided to fight for my place in all spaces, to push myself just as hard or harder than the next person, to give no one the excuse to shut me out, but rather shut them up.

This was the moment I decided to be a warrior for myself, my family, women, and specifically women of color.

Needless to say, we won that basketball game. Concluding the game, it felt great to high-five the opposing team and my archenemies with a smile on my face that said, *Never underestimate a girl, and certainly never underestimate me.*

CARMEN LoBUE

Film Director, Writer, and Actor

Born in Cleveland, OH

When I really think about standing up for myself in a way that brings me radical joy, I think about when I was in the fourth grade. I had a friend who I'd talk to on the phone every night and we'd go over our homework together, we'd talk about who we were crushing on in class, we'd go over our grades and work together to figure out how to improve them. We were planning for high school and beyond. We were both ambitious and very smart, but we were both maybe the *second* smartest, ya know? If either of us had a B+ we wanted to make it an A+, and we were desperate to help each other improve. We bonded over being the most athletic "girls" or in my case AFAB (assigned female at birth) in our grade. She and I didn't have all of the same friends, but we shared similar interests. We didn't look at each other like aliens either. She is white and great at basketball; I am Black/Filipino and was the fastest runner in our grade. We celebrated these things about each other. We didn't ever speak ill of one another or put each other down.

By fifth grade my friend and I had been separated. She was moved into another class next door. We didn't have the same homework anymore or the same classmates. But we'd see each other in the halls or at recess. We didn't stop being friends, but we naturally drifted apart. Keep in mind, fifth grade marked a time in my life when showing off wasn't limited to how white your sneakers were, how fresh you dressed that day, or who you fought at recess that day and whether or not you won the fight. It was also a time when everyone *had* to have a significant other. Welp. I made sure my grades were looking good, my outfit was fresh, and I had a boyfriend. He was the fastest "boy" runner in my class and dressed well. Our relationship was short-lived: I swiftly dumped him publicly after he fought someone at

recess and was then assigned detention. I didn't like violence then and I don't like it now. But peer pressure was so prevalent. Most little girls would want to be with the popular boy who beat everyone up. I never really fit in that way. I didn't know back then that I didn't identify as a girl. I was tomboyish and smart, and I was not a class clown, but I clowned on the bus ride home. I was known for the best "yo mama" jokes at the back of the bus. I entertained all the "popular" kids. I maintained my cool-nerd status by making people laugh every day. That's how I survived most of fifth grade until a terrible rumor started. The rumor was about how my fourth-grade friend and I were at odds. The rumors were spreading quickly: we weren't friends anymore . . . we fell out . . . we fought over a boy . . . we hated each other now. And soon enough, the rumor was that we were going to *fight* at recess.

It was so bad that she and I were called into the guidance counselor's office during school. I remember being so scared. I didn't want to fight her and she didn't want to fight me. We were honest about that to the guidance counselor. We were warned about expulsion for fighting, too. I also didn't want to get in trouble at home. So my friend and I came up with a bright idea: let's fake it! Let's play along with everyone. So we did. We participated in new rumors and spread the word about our upcoming fight. We told everyone we were going to fight at the top of the jungle gym. There was a bridge on top and we'd fight on the bridge for everyone to see. Leading up to the fight, my friend and I spoke on the phone each night and reported to one another about the lies we'd told. Then the day of the fight all the kids gathered around the jungle gym cheering on their projected winner. I was so nervous. The teachers also stood outside the building watching us without interfering. We each got to the top on the bridge and we hammed it up. I was taking off my earrings and putting my fists up. She was yelling and saying stuff. Then we charged at one another into a hug. We walked off together like, *PSYCH!!! Ya'll got PUNK'D!* Everyone went wild.

No reputation was ruined, no hair was pulled, no scars acquired. We fooled everyone. It was worth the nerves. I am so glad we didn't fight. To this day, I remember feeling the pressure of my peers. It took a lot of courage to stand together.

We trusted each other not to change our minds at the top of that bridge. We trusted that we were making the right choice. And we never lost any "popularity" points either. Actually, we gained some. Everyone thought it was really cool that we successfully played the whole school. Even our teachers were impressed. I think I learned a lot about my own character when I look back at that time. I am someone who cannot stand violence. I am someone who will stand up for and stand with *all* women. I am someone who will stand up to the patriarchal system that tries to pit the marginalized against one another. I am someone who enjoys clowning people, especially if it promotes peace, laughter, and unity.

KELLI O'HARA

Stage and Screen Actor

Born 1976 in Tulsa, OK

When I was eleven years old, my middle school PE coach decided that our entire fifth-grade class would do a physical fitness evaluation. This would include running a mile, which was four laps around the stadium track. We would each have a partner who would count our laps and time our journey. We could run the entire mile or walk it partially, but completing the task was the requirement. Assessing our speed would inform the level of our physical fitness.

At eleven years old, I was no athlete. I had never run long-distance or for any amount of time that was impressive, but I have never been one to let a challenge go unmet, even then. I was excited. I decided I was going to run my hardest, fastest, and farthest. I knew I could make my coach proud. I never thought for a second about the fact that I was a chubby kid. Sure, I had been made fun of relentlessly for years by girls and boys at school. Once I even had a group of girls weigh me, saying it was a prerequisite for joining their club. Needless to say, I failed to become a member.

So I was used to kids being mean, although I still have some scars deep down. But never did I imagine a coach—a real, adult teacher—would be the one to cause the most lasting scar. In hindsight, though, he inspired something useful in me.

That day of the evaluation, I was given a partner, randomly chosen. She was a girl named Gina White (I still remember all those names, the good ones and the bad ones). She was shy, also a bit overweight and probably the most honest, fair "lap counter" I could have wished for.

The whistle blew, the timer was started, and I was off. I was feeling great and having fun. With each lap, she would count and urge me on with a small, supportive

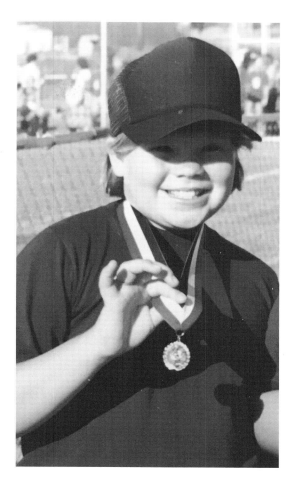

smile. Not only did I run the four laps without walking at all, I finished among the first in the class. I was really proud of myself. I couldn't wait for Gina to help me tell the coach. So imagine my confusion when Gina and I were accused of lying. We didn't know what we had done wrong.

At eleven years old, it was tough being told by a teacher that a girl like me could never run a mile in eight minutes. It was really tough when I was made to come back the next day and run it all over again in order to prove it. What was *not* tough was walking out of the stadium that day having bettered my time, settling the issue. What was also *not* tough was making the decision to never again let someone underestimate a chubby girl. After all, she might always be one on the inside even if not on the outside, and she'll need to know how to fight for herself. And I am. And I do.

BROOKE BALDWIN

Journalist, Author, and Former Host of CNN's *Newsroom*

Born 1979 in Atlanta, GA

There are several visceral moments (some as recent as *this* year and in this insane news cycle) where I've had to remind myself: "BB, speak *up* and keep going." And having just interviewed a number of barrier-breaking women for my own book, *Huddle*—let's just say their "not taking any shit" attitude has more than rubbed off on me. And I am grateful as hell to them.

But when I think back to the first moment of truly fighting for myself, I instantly flash back to my senior year in college in the journalism school building at UNC-Chapel Hill. The assignment was to write and shoot a "package" (that's TV talk for an edited, narrated piece on any subject complete with a "stand-up," where I film myself on camera). I was fortunate that my dad at the time traveled a lot internationally for work (and had a lot of Delta miles to spare), so he allowed me to tag along with him to Germany one long October weekend. I jumped at the opportunity to tag along to shoot a piece overseas! I packed up all my bulky camera equipment and lugged it across the ocean. Keep in mind I didn't speak a lick of German. That didn't stop me from finding an Oktoberfest event and setting up my camera, shooting everything myself, and interviewing Germans about the experience. (Did I mention I was twenty-one and such a good kid—I didn't allow myself a *drop* of alcohol! At Oktoberfest! I was hell-bent on being taken seriously as a journalist even then.) I shot all this material and then flew back to Chapel Hill, where I wrote, tracked, and edited my first piece for this broadcast journalism class. Y'all, I was *so* damn proud of myself. Most students went to the NC state fair and wrote about fried Snickers bars . . . and I went to Germany!

A week passed, and I got my grade back from my professor. There I stood,

thinking I'd aced the assignment. And there it was. Scribbled in red ink at the top of the page: 73. A C!!! And if that wasn't enough, the professor had added a note: "Next time try not to be drunk in your stand-up." I was DEV-AS-TAT-ED. I remember standing there, tears suddenly stinging my eyes. And for a moment I allowed myself to wonder, *Is this really the right profession for me?* That evening, I called a dear friend and fellow J-school student, Dana Rosengard, to tell him about what had happened. I'll never forget what he said to me: "Brooke, remember this moment . . . because one day you're going to be an anchor at CNN." And then he laughed and said, "Eventually there will be four zeros following that number seventy-three and that will be your salary. So you have to keep *going*."

Keep going. And in that moment I knew I would have to fight my ass off to make it in this career. I did fight for me and still do. Only now I fight for many of the people I interview—giving voice to the voiceless—with a platform I never take for granted. I remind myself to fight every damn day.

AISHA TYLER

Actor, Director, and Entrepreneur

Born 1970 in San Francisco, CA

There have been so many little moments, incremental beats of resolve or triumph that have added up, over time, to the person I am now. But one particular moment, when I was in college, feels resonant to me now. I was in a debate class, with a professor who was dismissive, abrupt, and patronizing in turn. He would cut people off, belittle their ideas, invite them to speak and then ignore them completely. I'm sure he believed this was the kind of tough instruction that would make people better debaters, but it did the opposite—it had a chilling effect on discourse in the class, as people were intimidated by him and afraid to broach innovative ideas or explore new areas of discussion.

It took me a while to realize that, specifically, he didn't think very much of women. I've always been a talker—I used to get sent to the principal's office all the time for chatting in class—but found myself shrinking under his tutelage, getting quieter and quieter in a class that was supposed to make us all better, bolder, more confident speakers. One day I challenged another student on a political point, and, like clockwork, he dismissed my point of view. When I attempted to defend myself, he shut me down completely, with something to the effect of "It's a poor point, poorly made. You don't know what you're talking about." I could see, however, from the faces of my classmates and the person I was debating, that I did have a compelling point and had been making it persuasively.

I was angry, and more than that, I was embarrassed, the kind of embarrassment that takes over your body, making you blush involuntarily, your eyes water, and dropping your stomach to the heels of your feet. But I was determined to not let him know he had gotten to me. Even though I was many decades his junior, I knew

he was the one being immature. I gritted my teeth and calmed myself, holding my tongue once again. As we exited class, several people sidled up to say they agreed with me, and my debate partner told me I had actually persuaded him that my view of the issue was the correct one. I exited class, stone-faced, walked into an empty classroom next door, and bawled my eyes out—the kind of explosive cry that happens when you are so full of anger you can barely think and it comes rushing out of your body in a torrent of uncontrollable sobs. I was angry at his pettiness and lack of maturity, at my own lack of bravery in the moment, and most of all that somehow he had forced me to lose faith in my own ideas and my ability to defend them.

I had a good cry there in that darkened room, and as I wiped my face I vowed in that moment what I knew instinctively in that classroom—that no matter what, I would never give him, or anyone else, the satisfaction of seeing that they had shaken my resolve. Sure, I've cried many, many times since then, during emotional moments of my life—I'm not a robot!—but I vowed I would never give anyone the enjoyment of seeing their cruelty manifested on my face and body. I would never let anyone see me cry again. And I never have.

MAYA WILEY

Lawyer, Professor, and Civil Rights Activist

Born 1964 in Syracuse, NY

Grade school for me was frightening. Not at first. At first, I went to a neighborhood segregated school for kindergarten, and I loved it. I remember the letters of the alphabet that circled the four walls of the room that we recited out loud with one of the two teachers in our classroom each day. I remember singing and laughing. But that school was closed after my one blissful year of kindergarten and we were all transferred to the other segregated elementary school a few blocks away.

Now I was in an overcrowded classroom with one teacher. I was bullied but never knew who the bully would be or when it would come. No one hated me. I was just odd. I was the middle-class kid with the daishiki-wearing Black activist father and the inexplicable white mother in a school filled with kids living with real struggles I had not known. Some days I was welcomed to play jacks or tag. But sometimes, even a friend could be pressured into attacking me. I was an easy target because I didn't know how to fight and was told I was not allowed to throw a punch unless I wanted to be spanked and grounded. I revered my mother because she was smart and beautiful and kind, and she was the most resilient person I have ever met. But that woman had no clue how to raise a kid in the hood. I asked my mother one day what to do if someone hit me. She gave me the worst advice possible. She told me to go tell a teacher. I paid dearly for it!

Then my life changed suddenly and dramatically. My father died and my mother transferred me to a private school. Overnight, the classroom was no longer overcrowded, and the teachers weren't exhausted and angry. They had first names and we used them. There was no fighting on the playground and there was grass. Grass! They had a field!

35

One day, Sammy, the "cool" boy in my class, and I had a disagreement. To this day, I can't remember what it was about, but the true disagreement was that I was refusing to pay homage to his greatness. He was surrounded by his clique—about three or four white boys, because most of the boys were white. Most of the school was white. Sammy said in a voice he must have heard some TV gang boss use in a movie, "Get her!" The other boys immediately jumped into action but didn't really know how to "get" me. I don't even think they understood the command exactly. Sammy didn't know what he wanted either. And I knew it. They weren't kids who knew how to fight, let alone why to fight.

So they ran at me and each tried to grab a limb. I had one on each arm and at least one other grabbing a leg. Now, in my old school this would have gone down differently. There would have been dangerously stoic eye-cutting and some very serious squaring up, indicating fists would be thrown. Movements would be slow and threatening. Everything would become briefly quiet. But you could not hesitate or lack any certainty or clarity of purpose, or you would become a target forever.

These frivolous boys lacked all clarity and certainty. I did not. It was clear these boys had it all: nice homes and cars and a school with grass. They had money in their pockets and lunch boxes instead of the trays carrying free school lunches. These white boys had no anger toward me because they had nothing to be angry about. I would not be looking for any teacher.

I started throwing down. The Black girl had finally learned what her classmates had been trying to teach her. Life is not fair or right. So fight. Fight to win even when it looks like you can't possibly. Fight because they try to make you bow down when you won't. Fight because you must.

They never touched me again.

MICHAELA PEREIRA

Anchor and Host at *Good Day LA*

Born 1970 in Saskatoon, Canada

The first time was perhaps when I was in elementary school and the only brown kid in my class or even maybe in my school at the time.

I was standing in the girl line for the water fountain and one of the boys said to me, "You're in the wrong line, you black elephant!"

I was a fairly girly girl with a bit of tomboy in me. I know, a walking conundrum. But I was *not* a fighter or a toughie.

You wouldn't have known it in that moment.

I grabbed him by the lapel and pushed him up against the wall and growled, "I am *not* a black elephant. And I *am* a girl."

Then I walked away.

I became acutely aware of being different then.

And have railed against "othering" ever since.

JOANNA GAINES

Co-owner and Cofounder of Magnolia, Chief Creative Officer of Magnolia Network, Author, and Entrepreneur

Born 1978 in Wichita, KS

As a little girl growing up in suburban Kansas who happened to be half Korean, shy, and a little bit self-conscious, I was teased in the same ways a lot of kids get teased at school. I spent my younger years trying to fit in as best I could, dressing the way the other girls dressed, acting as though I didn't get their jokes about my slanted eyes or hear their whispers when I'd opt for rice instead of fries in the cafeteria line, telling the other kids my middle name was Ann because it sounded more American than Lea (pronounced *Lee*).

Yet even the lies I told weren't as harmful as the lies I'd let take root in my heart: that the person I was made to be wasn't good enough, that I'd have to learn to push aside the part of my family's history that didn't seem like it fit into this world.

I got older, and eventually the teasing stopped, but by then I'd spent so many years hiding half of who I was from a world I thought wasn't interested that somewhat subconsciously I'd forgotten it was ever a part of me to begin with. It wasn't until a college internship took me to New York City that I realized I was going to have to fight to reclaim the chapters of my story that I'd shelved for so long.

New York is a mosaic of races, personalities, and cultures. I stepped into that city as a twenty-one-year-old and I'd never seen so many people who looked like me. I'd also never been so homesick. I spent my weekends in Koreatown, as much for the taste and scents and faces that reminded me of my mom as for my growing interest in the rich culture I found there. At first, it was our sameness that comforted me in a place that felt so big and foreign, but then it was the way they lived

in the fullness of their culture that drew me back. Finally, I was seeing the beauty of being different and the thrill of being unique. For the first time in maybe forever, I was proud of who I was, and I was realizing that the part of me that is different and that is unique really is the most beautiful part of my story.

I decided to get it all down on paper—listing all the names I'd been called and the ways I'd been poked fun at and all the lies I'd believed about myself on one side, and on the other side I wrote the truth about who I was. The quirky parts, the broken parts, the unique parts. I left New York feeling like a whole person for the first time in my life, believing that every bit of who I am and what I have to offer is mine to hold and to own and to use to make beautiful things in this world.

Lies like the ones I grew up believing about myself rarely disappear forever, and oh, do I wish they would. But I have come to believe that lies will always be worth fighting against, because then what you're left fighting for is the truth, and that's the most freeing thing in the world.

FERIAL PEARSON

Assistant Professor

Born 1978 in Nairobi, Kenya

I have lost count of the number of times I have been told to be nice. To be polite. To not be divisive. Every woman I know has been told the same, so I used to believe that this was how women were supposed to behave. However, I have come to understand that when we are nice, polite, and neutral, we are actually allowing awful things to happen—to us, and to others. We are siding with people who silence, oppress, and hurt others. My moment has been a slow burn for two decades, ever since I began to figure out as a young adult that the only way I can contribute to making the world a better place is to confront injustice head-on, and to speak up when something is wrong, even when my voice shakes.

Bishop Desmond Tutu once said, "If you are neutral in situations of injustice, you have chosen the side of the oppressor. If an elephant has its foot on the tail of a mouse and you say that you are neutral, the mouse will not appreciate your neutrality." People have told me with pride that they are not political. What I hear when they say that is that they are willing to turn away from oppression. I refuse to do that, because there have been many times in my life when I wished someone would speak up for me, validate that harm was being done to me, and understand that many times, the political is personal. The political dehumanizes people like me and allows violence into our lives.

In August 2019, I was invited to speak about my project, the Secret Kindness Agents, in a small village in rural Nebraska. The afternoon I arrived there, I was told by the superintendent that people had googled me and that since it was a conservative community, I should avoid talking about LGBTQ issues for my own

safety. As an openly queer person, this bothered me. That night, two Facebook posts about me from a woman in that village went viral. In them, she and dozens of others voiced their outrage that a "professed Muslim" would be speaking to their children. They called me a "wolf in sheep's clothing," a "great deceiver" with a desire to "transfer Christian power into Muslim power," who had an "evil message" that was "wrapped up in a deceitful package of 'kindness.'" They were calling for parents to show up to make sure I was not going to brainwash their children, and to protest my presence there. One parent was told to go to the school and be Chris Kyle, the American sniper, which I recognized as a possible threat to my life. I threw up. I wanted to drive the six hours home.

The next morning, I went to the high school to ask their advice about what to do. They felt terrible about what they had seen on Facebook the night before. They said they understood if I was too scared to be there, but that they hoped I'd stay. They told me that teenagers were worried about me. They had asked the county sheriff to be there to protect me. I realized my moment had come. I was the only brown, immigrant, openly queer Muslim adult within many miles of this place. The children needed to see me. They needed someone to disrupt the stereotypes they had been told about people like me. I decided to stay. I spoke, even though my voice and knees shook. Even though the protesters came to the school. And the children surrounded me with love, respect, gratitude, and hugs.

When I got home, I went public with what had happened to me and was scolded by many for being political, divisive, impolite, and not nice. Wasn't I supposed to be the kind lady? Wasn't calling out bigots unkind?

Some moments are bigger than one person, or five, or fifty. Some moments shift perceptions and make people uncomfortable so that they change their minds and become more inclusive. This was one of those moments. I owed it to the queer children in that village who were afraid to openly be who they are. I owed it to all the different kinds of people the children of this village would meet in the future

who would need allies and friends. My moment was *our* moment. We are all inextricably linked together and we owe it to ourselves to ensure that we all feel safe enough to belong. It is not the nice or polite thing to make bigots uncomfortable, but it is the brave and kind thing to do. Because it's the only thing that makes the community a better place than the way we found it.

ANNA GIFTY OPOKU-AGYEMAN

Activist, Author, and CEO of the Sadie Collective

Born 1996 in Kumasi, Ghana

At the age of five, after graduating from Head Start, a government program for low-income working families, I was selected by the county to enroll in a predominantly white private school near my family's home in Maryland. In 2008, I became its first Black graduate.

Despite my overall pleasant experience, I was well aware—at the age of five—that my classmates did not live the same lives as me and this remained true through high school.

Being the first, and sometimes the only, meant that you were often subject to racism in all of its forms.

I remember one day clearly. A white classmate walked up to tease me about how Black people eat fried chicken (unprovoked, might I add). He did this weekly, without fail.

I would always nervously laugh in response, hoping to defuse the racially charged situation by making light of it. That was how I coped, smiling and laughing even though I was seething, embarrassed, and, frankly, offended.

This time, however, was different. It was morning. His breath stunk, and I was tired. As he began to tell the "joke," I stopped him, looked up and down, and then

warned him, "If you continue with your joke, I am going to tell the teacher that you are being racist."

He stared at me in disbelief, confused and shocked.

I repeated myself, my voice shaking now. "If *you* tell another joke about fried chicken, I will tell the teacher that you have been bombarding me with racist jokes for the past few weeks. So if you don't want to get in trouble, you better not say another word."

He turned red—bright red—quickly apologized, and never uttered a word to me again.

From that day on, I realized that protecting my Black identity would be crucial to me navigating and surviving these kinds of spaces—the kind that allow whiteness and privilege to be absolved of responsibility and accountability. By standing up to him in all of my Blackness, I felt like I could stand up to anyone—so I did.

Months later, I cofounded my high school's first and only Black awareness club that gave Black and minoritized students space to candidly discuss our experiences.

I noticed how by being explicitly clear about how racism affected each of us, my non-Black peers and teachers were, in turn, more cognizant of how they treated us.

Even though I would still hear of racial incidents, no one dared to bring that kind of energy to me in fear of what I would say. And people knew that once Anna heard it, she would call it out immediately.

Understanding the power of my voice—how it could not only impact people like me, but also change those around me—led me to eventually direct and produce a documentary exploring how Black and brown students cope with micro- and macroaggressions from white peers and teachers.

Listening to how people who looked like me were afraid to stand up for themselves and how that stopped them from reaching their full potential made me realize that by using my voice I could demand that Black and brown people be centered.

ORLY MARLEY

President at Tuff Gong Worldwide

Born 1971 in Kefar Sava, Israel

It feels like I have always been fighting. Life is a struggle, especially for immigrant women—at some point you realize you have to start fighting back. That moment came for me the day my father was arrested in Iran as a political prisoner.

I am a first-generation Sabra: a Jew born in Israel to Iranian immigrant parents. My father moved there at fourteen and served in the Israeli Air Force. My parents married and had me at a young age. After the air force, my father was given the opportunity to go back to Iran with a lucrative job working for an international import/export company; my mother was all too happy to leave Israel and go back to be with her family. I was three years old when we left for Iran. We lived a charmed life. I was able to attend the only private Israeli school in Tehran. We took family vacations. We had a driver. The Israeli community was thriving in Tehran.

In the spring of 1979, everything changed. Iranian students began demonstrating against the shah's regime and the country went into a full-blown revolution. The Persian dynasty became a religious dictatorship overnight. Women and young girls were forced to cover up and wear the hijab. As the ayatollah took over, chaos prevailed. We (Israelis) became the enemy overnight and were no longer safe or welcome. The Israeli government told our entire community to leave immediately and come back to Israel. The last flight headed to Israel out of Iran, El Al 527 on Friday, March 14, 1979. We were all supposed to be on that plane.

My father made a decision to stay a few more days and finish up some work. He felt immune to the political climate since he'd been born in Iran. I remember hearing my parents discussing this, and my mother feeling uneasy about it. That was the worst decision of his life. Soon afterward, on one early evening my father

rang the doorbell, rather than use his key to enter our home. My mother later told me she knew right away that something was very wrong. My father was escorted in by several thug "soldiers" of the new regime; they ransacked our home looking for anything that would implicate us. They found our Israeli passports and some Israeli money and immediately took my father to Evin Prison. I was only eight years old at the time, but even then, I knew what just happened to us was not good.

I later learned that this prison—located in the Evin neighborhood of Tehran, Iran—was notorious for torturing and killing political prisoners, and for committing serious human rights violations against critics of the government. My mother and I were left behind; I remember turning to look at her and she suddenly broke down. She was crying and shaking; she was talking to herself, walking from room to room. I realized right then that my life would never be the same.

We ended up staying in Iran for another year. My mother enrolled me in a local public Iranian school. I learned to read and write Farsi, and every morning I wore a scarf covering my head and learned to recite the Koran. I had a thick Israeli accent when I spoke Farsi and got picked on a lot. I was not only Jewish, but I was Israeli, and Israel was the enemy. I remember there was a boy that would walk by me and pretend to slice his throat in front of me. Daily.

Thanks to the Almighty, and to a handsome "donation" to the regime, my father was released from prison. Physically he was back, but the man I knew never returned. My father never spoke about his time in prison, but I know it was not a bed of roses. Once out of prison, we were told that he was being watched by the new government. He couldn't leave the country. My mother, my newly born baby sister, and I were ordered to leave Iran. We could take a hundred dollars with us and nothing else. We obviously could not fly direct to Israel, as there were no flights going there from Iran. So we flew to Turkey, not knowing where our next meal would come from. Eventually my father escaped Iran on foot, and a year later we all reunited in Israel.

We spent four years in Israel, but my parents were never able to get financially stable again. When I was fourteen years old, we immigrated to the United

States. By this point we were a family of five, with my baby brother, who was born in Israel. Once again, I was left to learn a new language and conquer another new country. We were safe and we all worked hard. We shared a two-bedroom apartment in the flats of Beverly Hills so that us kids could attend Beverly Hills High School, which we were told was as good as public schools get. I worked multiple jobs through high school and college and graduated from Long Beach State College. I worked my way up the ladder at William Morris, becoming vice president by the age of thirty doing sponsorships and endorsements for musicians. Always fighting, always adapting. I now have a beautiful family with my husband and four kids and run a small management company in West Hollywood. I give thanks to the one above for giving me the strength and sense to be able to fight not just for myself but for my family and loved ones. I feel blessed and highly favored. All that we have gone through has made me the woman I am today.

PAOLA RAMOS

Journalist, Correspondent, and Author

Born 1987 in Miami, FL

A couple of years ago, when I met Karolina [Lopez] for the first time, I understood that I had to fight for *myself* in order to fight for *others*. It took me a while to reach this conclusion, though.

As a queer, Latina, first-generation American with multiple passports and confusing accents, I used to feel like I never quite fully fit in anywhere. I didn't see myself reflected in the telenovelas I grew up watching on Univision; I didn't feel like I could openly come out as a lesbian during our family reunions in Mexico; I didn't feel Latina enough in professional circles, American enough in classrooms, or Cuban enough in my hometown of Miami. Through it all, I always felt like I had to choose *one* side of me, *one* of my hats—never *all* of them—depending on which room I was entering. Yet after the 2016 presidential race, when less than 50 percent of eligible Latino voters actually showed up to the polls during one of the most consequential elections of our lifetime, I had a realization: How can we expect people to show up for themselves if they don't *see* reflections of their true selves anywhere? In that moment, I decided I was done wearing different hats: I was going to be myself, at all times.

Then, a year later, this feeling was reinforced when I met Karolina for the first time in Arizona, a transgender woman who had fled Mexico. With her, I realized that fighting for yourself can be a privilege. The reality is, some people don't even get a chance to fight for dignity, because their lives are deemed too unworthy. And when all odds bet against you, it's easier to give up. Karolina has never given up, though, and *that* has taught me an invaluable lesson: when I feel defeated, I think of Karolina's resilience.

It keeps me going.

After fleeing violence in Mexico many years ago, Karolina migrated to the United States to search for better opportunities. In Latin America, the average life expectancy for transgender women is thirty-five years old. But even though this country promised Karolina hope, she was never really met with it. All she wanted to do in the United States was have a shot at an education. A shot at stepping into a classroom. Instead, Karolina was detained by ICE, harassed by officials, and even after she was released, she's faced discrimination time and time again. Karolina has told me that there are many times when she has felt like giving up. But she never did: she continues to hold onto dreams that deem her worthy of imagining a better life for herself.

Meeting Karolina made me realize that not being my full self—not fighting for myself—meant giving up on her.

HETAL JANI

Educator, Social Entrepreneur, and Advocate

Born 1983 in New York, NY

I was in the first grade when I learned that the name my parents had given me didn't have a place in America. My name is pronounced kind of like "Ethel" with an *H* in front—well, not really, but that's what my name has become, an explanation. I remember the back-and-forth exchange I had at the beginning of the school year with my first-grade teacher, Mrs. Zimmerman. She couldn't hear well how I

was pronouncing my name from where I was seated at the opposite end of the classroom. I can still feel the humiliation and frustration I felt with her, but more so with my own name. I dreaded the walk up to her desk so she could try to better hear how I was pronouncing my name. Eventually, she gave up and told me she would call me "He-tall" and, so, I became He-tall, and have been learning how to pronounce my own name incorrectly for most of my life since. I would go on to have a great relationship with Mrs. Zimmerman—I really did love her. In fact, as an educator, I find myself

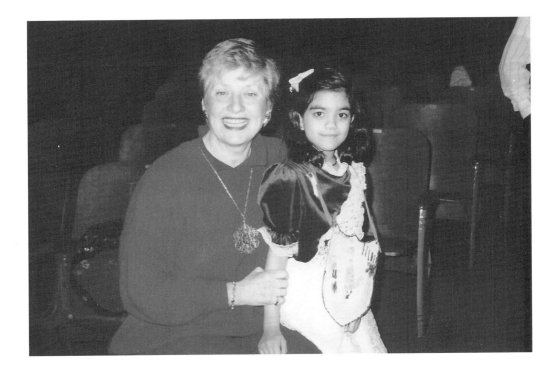

emulating what I appreciated most abut her as my teacher. But that single deci-
sion she made about pronouncing my name stayed with me forever.

I always felt like two different people, one when my name was pronounced
correctly at home and the other when it was pronounced incorrectly in most
other places. It also meant I was Indian at home and that to be American meant
accepting that my name would be mispronounced everywhere else. It wasn't easy
to correct people, because it made me relive the humiliation I felt in the first
grade, so hopefully that answers any questions of why I didn't just correct people
when they said my name incorrectly. I had tried a lot over the years. Depending
on where I was, and how much effort people made, I even gave changing my
name serious thought a lot throughout my life, and my mom supported me in that
deliberation. I wanted to have a "simpler" name, but really that meant I wanted a
more Anglo-sounding name, like whenever I played pretend and referred to my-

self as Tiffany, Brittany, Brenda. I never gave my dolls any Indian names, and I rarely ever pretended I was Indian.

If I'm in a crowded place, I usually just go with my last name, which is pronounced like "Johnny." In April 2020, I was a panelist at a conference for school counselors preparing to go back to school after Covid and support their especially vulnerable students, which includes a diversity of students, and, so we planned on discussing how counselors can be culturally responsive to their students' unique needs. Naturally, this was a place where I definitely would correct my name pronunciation, but it also had become so normal for me to at least introduce myself, "Well, my name is kind of like 'Ethel' with an *H* in front," if the person made space for that kind of introduction. But this time when I corrected my name, another panelist, HuyenTran Vo (Hwin-Jun), interjected to say that she had never heard someone correct anyone else about their own name and do it so effortlessly. Over thirty years, she had just let people call her whatever they wanted, and that usually defaulted to her last name, Vo, but saying it without asking her how it was supposed to be pronounced. (Note to most readers: you're likely not reading it how it should sound.) Given the topic of the talk, we made space for her to think aloud and not only come to terms with pronouncing her name out loud for everyone to hear—and, really, for herself to hear—but also to correct someone on the pronunciation of her name since she had been introduced with her last name pronounced incorrectly.

HuyenTran and I agreed to meet up after because we clearly had more to talk about, and in that conversation I realized how frustrated I was about a recent fellowship I had just completed focused on lifting up professionals from diverse backgrounds, where most of the other fellows never even bothered to ask me how to say my name correctly or tried to say it properly, even though I had said it multiple times during our sessions. It made me feel disconnected from them, and I had a hard time feeling welcomed and included in the fellowship, or that it had any value to me as a professional, with all of my diversity. So, in that conversation

with HuyenTran where she mulled over how she felt when people never even bothered to ask her her name, I realized I was done, tired of people who were working especially on diversity and inclusion but not realizing how to do that fundamentally by asking someone how to pronounce their own name and then trying to say the name properly. That's when I had enough and started the #SpeakingMyName campaign. Respect starts with a name; it's that simple.

BRANDI CARLILE

Singer-Songwriter and Producer

Born 1981 in Ravensdale, WA

The moment I first learned I would have to fight I was standing near the altar of my Baptist church as a teenager while the pastor refused to baptize me in front of my family and my community.

I had been led to believe that I was unilaterally accepted in my humanity by my church and friends. The purpose of this particular spectacle was humiliation and reproach.

I knew then that there was no length that people won't go to hurt one another when they are afraid. Afraid of God, afraid of sex, success, isolation.

This is when I realized that if I could be humiliated on a stage, could I not also be renewed and accepted on a stage? To emerge from this event victorious again and again? At Madison Square Garden, Red Rocks, and the Ryman. If I just found another vehicle for the soul? Music, art, performance, and the strange sexual and intellectual expressions are their own baptism. God is in them.

"It's not a cry that you hear at night, it's not somebody who's seen the light, it's a cold and it's a broken hallelujah."

DAISY FUENTES

Model, Actor, TV Host, and Entrepreneur

Born 1966 in Havana, Cuba

I was timid as a kid. I was taught to respect adults and not speak out of turn. As I got older, when I started modeling, I was treated as a product/thing instead of a person. The fashion industry was rude and cruel, especially toward young, inexperienced, vulnerable girls. One day on a shoot for a popular Spanish-language magazine, the stylist was rudely complaining to the photographer about me as I was changing into my next outfit. She said, "She's a local TV girl. I thought this was with a real model. She's a nobody!"

She knew I could hear her—I was just on the other side of a curtain. I felt horrible.

She was a very experienced, highly sought-after stylist, and I didn't know what to do or what to say, but I knew I didn't want to work the rest of the shoot with such an unpleasant person.

I took off the dress, gave it back to her, and said, "You obviously don't want to work with me and you shouldn't have to . . . so here's your dress back." I apologized to the photographer and said, "I'm not wearing any of those clothes and I don't want to work with anyone who's so mean and rude."

The photographer was shocked that I spoke up for myself, and she was totally stuck in a hard situation, so I suggested we just shoot in the black catsuit I'd worn to the shoot. We had no other choice. The stylist left (outraged) with all of her clothes, and I landed the cover of the magazine with my one wardrobe option that I wore off the street. Looking back, I'm glad I spoke up for myself. I was nineteen and it was the beginning of me taking absolutely no shit from anyone. Ever.

KIMBERLY REED

Film Director and Producer

Born 1967 in Helena, MT

I had a business meeting years after I'd met with that same person prior to my transition. I saw how much less respect I garnered as a woman. That made me really want to fight for more respect!

Though I don't think I've ever been quick to fight for myself, there was a time in a restaurant on Christopher Street in New York when I was meeting six to eight trans people for dinner. This was in the early 2000s.

I arrived last, and passed a table of gawking straight couples at the next table who were laughing at my friends' table, pulling out their cameras to take photos, and so on. Before I knew it, I was dressing them down, asking them to defend what they were doing, telling them the people at the next table were people, not exhibits. They were really shocked and silent. It's the disrespect that really sets me off!

MELISSA PETERMAN

Actor and Comedian

Born 1971 in Edina, MN

For me, it was difficult to define a single moment when I decided to start fighting for myself. I thought I needed to tell a story that was epic, where I bravely stood up to a bully while a crowd cheered, or single-handedly took on an industry that thrives on belittling and silencing the voices of the marginalized and brought them to their knees. I struggled to identify my moment because I know women who have done those things. I know women who had the courage to leave abusive situations. I know women who took control of their lives and careers. I know women who no longer waited for someone else to tell them yes and carved their own path. And I am in awe of their bravery and strength. But the more I thought about it, I realized that my moment didn't need to be big to be huge for me.

One of the small but important moments in my life happened very early in my career when I was on set. It was a kids' movie and I had a fun part. Greg, the amazing head of wardrobe, was getting me into a dress for an upcoming scene. Even at my fittest, at almost six feet tall, I've never been what you would call a "sample size," and we were struggling to find the right look. The director wanted to see me in the dress and asked for me to come to the set so he could see it on me. In front of everyone—the cast and the crew—he discussed all the reasons it didn't look good. It was as if I wasn't even there. I was mortified. When Greg and I left the stage to head back to the dressing room, he was so kind to me. He knew what had just happened was wrong and he immediately told me that we were going to go shopping to find something I would feel good in, budget be damned. Off we went. When we returned to the set with a new dress, I told the director if he wanted to see me in it, Greg and I would take a picture to show him and if there was an issue,

he could discuss that with wardrobe in private. I would not be walking to the set again.

Nobody cheered, I didn't bring an industry to its knees, and the director probably didn't even know he had made me cry, but I felt like a person again. I realize I chose a career where "the talent" is a commodity. You are replaceable. You get parts because of how you look or don't look. I have been in rooms while my height, my hair, my body, my age were discussed. Never my comedic timing or talent. "I just wish her timing was thinner". . . or "if only her talent was younger." I know a thick skin is necessary, but since that small moment early in my career when I listened to that inner voice that said, *This is not right,* it's gotten easier to trust that voice and to use my own. Women are used to having our looks picked apart and more often than not the harshest critic is the one in the mirror, and trust me, she can be an unreliable witness to her own strength and beauty. She's the one who told you you were fat and ugly when you were seventeen. Come on, you've seen those pictures—YOU WERE GORGEOUS!!! Clearly that girl in the mirror could not be trusted.

But that moment wasn't about my looks. That wasn't what felt so bad. What was wrong was that I was made to feel invisible, like I was just a thing holding the dress up. Voiceless.

But I am here. And I am not replaceable. I will turn fifty this year. The age where the joke is that women actually become invisible. I plan on being seen. I plan on being heard. I plan on getting louder. My inner voice and my outer voice.

P.S. Although if anyone knows Wonder Woman, I would like a ride in her invisible plane for my fiftieth birthday. Now that would be an epic story.

P.P.S. Next time, I'll tell you the story of the male comic who told me right before I went onstage that it didn't even matter if I was funny, because I was pretty. Spoiler alert: both of my voices had a lot to say.

JANELLE MURREN

Childcare Provider

Born 1978 in Trinidad

I am the much younger sibling of six kids. I was very young when my brothers and sisters began having children, so I have been babysitting from a tender age and it's no surprise that I've made a career in childcare. I am a nanny. I love my job and I take great pride in it. I have always worked for wonderful families that made me feel like I was part of theirs.

In 2010, I began working for a family that felt like a good fit and I was prepared to spend the next five or so years with them, which is the average in this line of work. They needed me for long hours, and by the time I added in my commute, I was working twelve-hour days, but I was glad to be with this family. The baby was three months old and she was just perfect.

After the first year, I noticed some changes, but I knew enough to know that every family is different and everyone has flaws. I'd begun to witness some disrespectful comments that the child's father would make toward his wife and even to his own mother; which astonished me. Never in a million years did I believe it would ever be my turn.

In 2011, there was a freak storm and we lost power for a week. There was no way to refrigerate anything, so we had to buy and prepare food daily. One day, we were all home at the same time. The wife said to the husband, "You need to run out and get some lunch for Janelle."

His response was angry and loud. "Have to f***ing pay her and feed her too?! Do I look like her husband?!" He grabbed the car keys and left.

A shiver ran through my body, I felt sick to my stomach and my feelings were

crushed. When he came back with the food, I didn't touch it and I didn't think they even noticed.

My husband always picked me up from work and the moment I got in the car, he knew something was wrong. When I told him what happened, he almost lost his mind and it took a lot for him to not turn around and confront this man for disrespecting me.

After a night of soul-searching, I knew that I couldn't go back. The next day when I didn't show up for work, they called and texted me until I finally picked up my phone.

I simply told them, "I am not going to leave my kids alone—which is a hard thing to do—to take care of yours and be humiliated." The husband called my phone the entire weekend. He rang my doorbell and he even sent flowers.

My final words to him were, "I may be hungry, but I'm not starving."

It was scary walking out on my job that I really needed on that Thursday evening. But God is good. I started a new job the very next Tuesday. And my commute was five minutes.

I cried a lot of tears over the whole ordeal and I missed that little girl for a long time, but I did what I had to do.

MARLO THOMAS

Actress, Producer, Author, and Social Activist

Born 1937 in Detroit

I was one of those lucky girls who had a dad who believed in me, stood by me, and took my side no matter the confrontation. He was, quite simply, my champion. So I had a good amount of confidence. I would need it as I started out on the rocky journey to becoming an actress.

Right away, I could see that this was not even close to being an easy road for me. First off, I didn't look like the girl next door, which was a place reserved for blue-eyed blondes like Sandra Dee and Doris Day, who I most certainly was not.

But I kept on plugging. I studied, did workshops, appeared in small plays (even got good reviews), auditioned for everything I could, took meetings with anyone who would meet me, and knocked on any door I could find.

And I was getting nowhere.

Finally, my father couldn't take watching my frustration any longer and begged me to let him set up a meeting with a producer friend of his, Mike Frankovich at Columbia Pictures. I felt uncomfortable doing it, but I went. I sat across from Mr. Frankovich feeling small, desperate, and hopeful.

He began by telling me what a great guy my dad was, while I tried to bring

the conversation around to me and my work. Mr. Frankovich looked at me dismissively.

"Why would a lovely, educated girl like you want to be in this lousy business? Why don't you marry your boyfriend and give your father some grandkids."

It was humiliating. I called my father, told him about the meeting, and drew a very clear line.

"Please, Dad," I said, "don't ever—*ever*—make any calls on my behalf. I'm going to have to do this on my own."

But as I continued to try to make my way, it continued to eat at my father that I, his beloved daughter, was pounding the pavement in vain. So one night he decided to talk to me about it.

He spoke to me in very plain language, as he always had. "If you wanted to be a solo performer, like a singer or a comic," he explained, "you'd always be able to find work just like I always have. But actors are too dependent on others for a job.

"And," he continued, "if lightning was going to strike it would have by now. I know this business. You are not going to make it. You tried. You tried hard. But it didn't happen and it's not going to happen. So get out now before you become a frustrated and bitter young woman."

The more he spoke, the more upset and insistent he became.

"You are a well-educated and strong young woman. You could be a senator, for God's sake! Why would you pick something at which you cannot succeed?"

I couldn't believe it. After all the years of unconditional love, of encouragement, of support in everything I did as a kid, he had withdrawn his belief in me.

I got up from the table and walked to the doorway. Then I turned back to him and spoke in a voice so deep it could have been used in *The Exorcist*.

"Not only am I going to make it," I said in a fury, "but someday you and your partner, Sheldon Leonard, are going to want to hire me, and you won't be able to fucking afford me!"

And I stormed out.

Later I learned that my mother had overheard it all and had immediately gone to my father.

"Don't you think you were too tough on her?" she said. "Maybe you should go after her."

"No, let her be," Daddy said. "If she really wants it, she'll have to face a lot tougher rejection than this."

The irony is, not only did I make it, but even with my brown hair and brown eyes, I made it as the ultimate girl next door. No one was more relieved—and more proud—than my doubting-Thomas father.

KRISTIN CHENOWETH

Actress, Singer, and Author

Born 1968 in Broken Arrow, OK

When it comes to standing up for other people, I'm like a lion, but I've never been quite comfortable standing up for myself. It's always sort of bugged me, but I was never willing to spend a lot of time thinking about it because that stirred up some hard questions for me—about self-worth, about what I deserve, and about facing the fact that being a woman is often a liability.

On July 11, 2012, I was on a TV set in Brooklyn, filming a show called *The Good Wife* for CBS. As I stood on my mark, awaiting the next shot, a piece of lighting equipment crashed down on top of me and knocked me back into a curb.

I was rushed by ambulance to Bellevue Hospital in Manhattan. My injuries were severe. My ribs were cracked. My nose and some of my teeth were broken, and I had a skull fracture. And those were just the injuries that actually showed up on X-rays; never mind the nerve, tissue, and muscle damage I'd have to face in the weeks, months, and years that followed.

Although there was a good deal of media interest in the accident, I tried to keep it all very quiet. There were a couple of reasons why.

I didn't want to be viewed as weak. In the entertainment industry, as is the case with so many other lines of work, when someone considers hiring you for a part, they want to know that you're ready to run. Ready to work the long hours. Ready and able to push as far as "getting the job done" might require. I have always been known for that: "Cheno is a workhorse." It's been a big part of who I am known to be, and I'm proud of it. My parents instilled in me a fierce work ethic.

So I kept the extent of my injuries quiet because if I let the truth get out about how badly I was hurt, it would certainly cause me to be seen as weak and broken.

And when you're a woman in this industry, that perception of weakness is inherently baked into the cake from day one. I didn't want to feed into that negative stereotype.

The other reason I kept it quiet is because I didn't want to be "a problem" for CBS. I was advised by a couple of folks on my team and outside of my team too that it would be unwise to attempt to hold CBS accountable for what was clearly their responsibility. I mean, actors have worked entire careers in film and TV without pieces of heavy gear falling on them. Imagine that.

I was told that I'd never work again if I sued a major network. And that scared me. I let fear take over and did what so many people do—especially women—in the face of going up against someone or something more powerful than they are. I shrunk.

A few months after the accident, I was headed into a dentist appointment and there were paparazzi outside who took my photo and posted it online. I was told by my attorneys that CBS called them right up and said, "Judging from the pictures out there, Kristin appears to be doing GREAT!" I wasn't doing great, but my sucking-it-up smile for a paparazzi photo was weaponized against me, and again, I felt intimidated. Not to mention, it's no secret that if we female celebrities dare not smile or are less than friendly when someone is snapping our photo in public, we'll be called particular names saved exclusively for us girls. It was all such a trap.

In the years since the accident, I've dealt with hundreds of doctor appointments (no exaggeration) and head-to-toe pain on a daily basis, and that fear I used to have—which had been the big decision maker for me—has been eclipsed by a lot of other feelings.

I finally got mad about the whole thing. The injustice of it all finally began to take up more space inside of me than the fear did. Which is why I've recently begun speaking out about the chronic pain that I've dealt with since the accident.

I guess it's my way of taking a first step in fighting for myself. I'm telling my story about what happened, and I really don't care if CBS never hires me again.

They knew I was hurt really badly, but they exploited the power they held over a person like me. I'm a working actor—key word *working*. Unfortunately, the powers that be at CBS at the time did not take responsibility for what happened to me, but there's a new regime at the network and they're just lovely to work with. Leadership matters. Full stop.

There are a lot of people out there in the world dealing with pain; many of them hurting as a result of an injury at work. Still, they press on and do their best to keep working and to keep living. That is cause for admiration, not shame. I celebrate you.

And finally, I want to say this to girls and women. Try not to operate from a place of fear like I did for so long, but rather, listen to the voice inside of you that knows you are valuable and strong. Listen to that voice, girls. She's your guiding light.

JENNA USHKOWITZ

Producer, Actor, Singer, and Podcast Host

Born 1986 in Seoul, South Korea

I don't recall there ever being an *a-ha!* moment for me. It was more like a series of unfortunate events that led me to *learn* how to stand up for myself.

As a child actor, I learned very early on how to be cooperative, take direction, and be a "team player." I would come to find that those qualities of adaptability seeped into every facet of my life, causing me to become a total people pleaser.

In my career, I was warned that being a woman and minority in the entertainment industry would make it more difficult for me to succeed, so I never wanted to rock the boat. In school, I played by the book and with friends, I became a welcome mat, being pushed around and taken advantage of, always being the easy, go-with-the-flow gal.

As I grew older and began dating, I found that I was compatible with a lot of the guys I was seeing because I was adapting to their lives. (Ironically, I've always been independent and never had any problem being happy alone.) But as I fell deeper into these serious relationships, I lost sight of what I wanted and I voluntarily became second fiddle. My relationships were repeatedly one-sided and I was always making sure the other person was happy. "I'm fine" would become the phrase of my twenties. I would have rather shoved all my feelings down inside and not communicated my frustrations and truths in order to maintain stability and not create conflict. I would find a way to navigate through those feelings on my own.

I believe being in a relationship is like looking in a mirror—you learn as much about yourself as you do about your partner. The more and more I diminished myself, solely to not make any waves, the more I became exhausted carrying this weight of anger and resentment with my boyfriends. This was a pattern I needed to

break. Like a teakettle boiling over, I was ready to emerge and was tired of silencing my own voice.

It really began to sink in with one guy I was seriously dating in my early twenties. He took advantage of my easily swayable nature, so much so that I was manipulated to believe he was the only one I should trust. I lost close friends along the way. When he assisted with preparation for auditions, he'd take the credit if I booked the job, saying *he got me the job*. Somehow, I continued to fall deeper into his trap, and one night in particular, I got in a fight with my parents over something silly. I was so upset when I hung up the phone and was feeling alone. He told me to get over it and proceeded to say, "Snap out of it! What are you, stupid?"

Well, I certainly did snap out of it. I began to realize this was a toxic person and a toxic relationship and that he took full advantage of me "going with the flow." It took me some time but I eventually learned that self-worth, self-love, and confidence were the foundation I was missing to trust that my voice matters and, most importantly, that my happiness was *just* as important as everyone else's. The awareness I have gained and the work I have done have become the most valuable of tools to realize when I can be a great team player and when I should speak out and stand up for myself.

Besides, rocking the boat is way more fun.

MANDANA DAYANI

Creator and Cofounder of I Am a Voter

Born 1982 in Tehran, Iran

I remember the day we arrived in New York City. I was five years old. New York was the largest, most terrifying place I'd ever seen. There were so many people and lights and unfamiliar sounds. I held my mom's hand as tightly as possible. It would be okay, I told myself, because we were together.

As refugees living in America, we tried desperately to assimilate. We wanted so badly to be accepted and to fit in, to have a new, permanent home. This aligned with much of how I was raised. The granddaughter of an Orthodox Jewish rabbi in Iran, I was expected to be a good daughter and an upstanding and respected member of our community. One who never dared upset the status quo. I was to be the perfect little Jewish girl.

And so I did all the things everyone expected of me. I became a high-achieving attorney and executive. Married with kids by a certain age. An amicable, people-pleasing peacekeeper. And despite all the happiness the people in my life brought me and the successes I achieved, I knew I wasn't being honest with myself. I wasn't honoring my purpose or my voice. And I felt incomplete. Suffocated. Somehow, in my desire to create the facade of perfection, I had buried what I really wanted.

Three years ago, after my second daughter was born, I was watching the news while making her breakfast and I saw video clips of children lying on the floor. Inside cages. Under aluminum blankets. Crying. Screaming out for their parents. Refugees from countries fleeing violence and persecution, who had made the bold, brave decision to come to our great nation. The same nation that welcomed my family and gave us this beautiful life was ripping children from their parents, abandoning them, and tossing them aside.

My insides imploded. What happened to us? How did our country get so broken?

To think that after what was likely the most horrifying conditions at home and months of a brutal journey to our shores, that we would treat the world's most vulnerable people this way, that we could dare tear children out of their parents' tired arms and break the promise inscribed on our Statue of Liberty—it was just the absolute most horrifying atrocity I had ever witnessed.

I booked a flight to Tornillo, Texas, to see the first of the camps where the separated children were being held. I had to see it. It was almost impossible to believe it otherwise.

Walking up to the tall fences that enclosed the camps, I knew that my voice was a privilege. I decided to get loud in the ways I knew how. And I vowed to never stop. Even if it makes others uncomfortable.

Especially if it makes others uncomfortable.

JENNIFER ESPOSITO

Actor and Author

Born 1973 in New York, NY

If you would have asked me this question a couple of years ago I would have answered very differently. You see, where I grew up, yelling, fighting, and deep rage from both inside and outside my home were normal. Speaking up and fighting were what you did to survive.

As a young adult, I learned very quickly that being a female who spoke up for herself and others was not only not acceptable but punishable. Sure, maybe my delivery wasn't always great and my idea of what speaking up meant wasn't quite right. I beat myself up for years trying to become more "acceptable," to become what I was being told I should be. Bending myself into a pretzel trying to be better, more agreeable, more likable. Until one day I realized I was never fitting into the mold set out in front of me.

Exhausted from fighting or defending who I was or what was right, I just stopped trying. It was in that surrender that I finally realized where the power exists. It's in my own acceptance and permission to be exactly who I am. That standing up for myself didn't have to be brazen and outward. It could be a quiet power of true self-acceptance that screamed louder than any words I could ever speak.

SHAKINA NAYFACK

Actor and Transgender Activist

Born 1980 in Ventura, CA

It's different—
Because I didn't choose to be here
Or this way
Or that way
But I made a place for myself
And it fits
Tight
Like your ass
Like my fist
Like the noose you tried to hang us
 from
But I
We
Broke free
Unafraid to hold hands when we
March
Into battle
For our sex lives?
Those white lies
Do you more harm than you realize.
Take it from a pro
At swallowing
PRIDE

I'll sing from holes so deep
They're only found in your new-age
 section
I'll scream from the mountain peaks
Peaking
Higher than you can get with any
 drug—
My anger has evolved.
Lifted me to a state of being
The majority cannot comprehend.
And I have no obligation to you
But to the children under your feet—
To the souls you crush
With your collective
"Why's he gotta be so . . .
"Look at the way she . . .
"Who do they think they . . ."
Are you ready to face the mirror
You forced me to hate?
Can you look at me
Look at me
Look at me
And honestly wonder

Why I put myself up here
Out there
Anywhere I hear the muffled cries of
My people
PEOPLE
Suffocating beneath the rug you
Swept them under?
—Over the top—
The "top" is a lid you screwed on
When you realized your power
Doesn't mean shit.
I see you're scared now
But my words could never hurt
As much as your ignorance

COMPOSITIONS

SHOSHANA BEAN

Singer-Songwriter, Actor, and Recording Artist

Born 1977 in Olympia, WA

I spent my twenties fighting for myself and for my place in the world somewhat fearlessly and diligently. It seemed to come quite naturally, like a default setting. As life continued to happen and leave its little paper cuts all over me, I woke up nearing my fortieth birthday wondering where that brave young lady went and when that fire she previously possessed ceased to burn. Why had her self-worth diminished so greatly? When had she begun to make excuses leaving her paralyzed with fear? When had she begun to live safely instead of bravely?

The business of entertainment has the ability to make an artist feel like aging is certain death to a career. But as forty approached, I refused to believe I was anywhere close to complete! I decided to make forty a rebirth of sorts. I decided to find that fire again, but this time, armed with the beautiful wisdom and perspective that only forty years of life can provide.

I took the biggest risk of my career by setting out to make the largest, most involved, most expensive album I had ever made. Independently. Everything in me fought to stay safe and comfortable. Everything in me begged to play small and stay small. Everything in me reasoned that it would undoubtedly end in a mess of failure. And yet I pushed forward. I felt intense fear and kept moving anyway.

I realized I had been waiting for and expecting others to take chances on me, when I had only been willing to take limited chances on myself. I had slowly, over time, begun to believe that I wasn't worthy. It occurred to me that if I wasn't willing to fight for myself by moving bravely through fears and limits designed to protect me from feeling disappointment or the pain of rejection, I would most certainly

continue to live a life that was safe and small. I was no longer willing to exist so far from my fullest potential.

What I came to find was that all the sweetest, most joyful, delicious rewards lie on the other side of fear. Each courageous move led to even more scary territory still. But I remain committed to staying where it's uncomfortable, to taking risks and continuing to press on through the fear to the wonderful goodness waiting on the other side. Living in this way, I have found that life just continues to get sweeter and sweeter.

EMILY CAIN

Executive Director of EMILY's List and Former Maine State Legislator

Born 1980 in Louisville, KY

For someone who was elected to office at the age of twenty-four, you'd expect me to answer this question with a tale of righting some wrong at a young age, serving on student council, or being inspired by a political science class I took in college. Nope. That's not me. I majored in music education and "politician" was never on the list of things I wanted to be when I grew up.

Now I'm forty. I have won five statehouse elections and lost two elections for Congress. For the record, winning is better. I wish I'd won them all. But what I realized through losing is what this story is about.

When I lost my first race for Congress in 2014, it was a surprise to most people, including me. I conceded the race in the middle of the night and I woke up the morning after the election alone in a hotel room in Bangor, Maine.

I was afraid to open my eyes. My husband had left early to collect yard signs and I was in bed wide awake with my eyes shut. I didn't know how I was going to feel when I opened them. I did not have a plan for that. I did not have a plan for losing. And when I finally got the courage to open my eyes, I somehow found it surprising that the hotel room looked the same as it had the night before.

I got out of bed and went into the bathroom, and when I looked in the mirror, I remember being surprised that I still looked like myself. I just had to take a shower and start fresh. It was a big hotel room with two rooms and a big bathroom. There was a big bathtub and it had a big shower with a lot of showerheads. A sexy shower.

I got into the sexy shower and started to do my normal shower business. I washed my hair. I washed my body. And as I was washing my face, I suddenly became overwhelmed. My heart started racing and my chest felt heavy. The tears

came fast. I couldn't stand. And those sexy shower jets were coming at me from all directions.

I reached for the tiled wall and held on to the soap holder to try and reclaim my balance. But there I was, crouched on the floor of the sexy shower, sobbing. I was wailing. The kind of crying that overcomes your entire body.

I was letting it all out. The long days and nights. The sadness of letting down my family and my team and my supporters. The worry that the people and communities I cared about and ran to help would be forgotten. The eighteen months of work and stress and emotion that had built up to a promise of elation that fell just a few percentage points short. The enormous sense of loss that comes from losing.

I don't really know how long I was in that position, but I remember suddenly feeling the sexy shower jets on my back and on my arms and on my legs. I could feel them on my head and my face.

And I started laughing.

As my wails turned to full-body laughter, and I started to stand, I heard words—my words—forming a sentence, coming inexplicably from my mouth, clearly saying: "This is *not* what a sexy shower is for."

And as the laugh got louder and freer and I got my feet under me, I said again: "This is *not* what a sexy shower is for."

And in that moment of laughter and absurdity, that's when I knew I would be okay. No. That's when I knew I was already okay.

Because I had never been in it for the title. I had been in it for the work and the people whose lives I wanted to make better.

That's when I knew that if I decided to run again, I would do it unafraid to lose. I had run as my whole self. I was still intact. All of me was still there, only better and stronger.

And when I lost again two years later in 2016, after running an even better and stronger and more authentic campaign, as it felt like Armageddon had come to American democracy, I was still okay. I knew I just had to find another way.

GLORIA STEINEM

Author, Activist, and Organizer

Born 1934 in Toledo, OH

It was sometime in the 1960s. I was in my early thirties, and I was sitting in the office of an executive whose name I can't remember, waiting for him to return. Next to me on the leather office couch was Terry Southern, a man I knew slightly as an author and a screenwriter. We were talking about nothing much, waiting for this mutual friend.

Suddenly, Terry reached over, held down my hands that were clasped in my lap, and tried to kiss me. In a millisecond and without thinking, I bit him on the cheek. I only realized this because as he pulled away, I could see a tiny drop of blood, but the moment was over as abruptly as it began.

Ever after that, if I happened to see him in the Russian Tea Room, which was where writers hung out in those days, Terry would point to his cheek and insist there was a scar there. I wasn't angry and neither was he, but it was a shared recognition.

A few years later, as women's truth-telling created feminism—and vice versa—I realized that I was just about the only woman I knew who had never been sexually harassed, raped, or even pressured into having sex I didn't want. As a child, I had never been hit or abused. By the accident of having kind parents, not going to school very much, freelancing instead of having a job I could be fired from, and just dumb luck, I had retained the catlike instincts that we are all born with. I realized just how precious those natural reflexes are.

I bet that if we are not scared, pressured, or punished—by child abuse, religious training, the tyranny of gender roles, survival sex, or sexual assault—we all have the responses of a cat. But the more we respect children's bodies, ask before

we hug and kiss a child who may not welcome it, refuse to normalize forced submission in behavior around us, or to sexualize violence in our homes or in our movies, I bet the more we will discover that we all have the instincts of a cat.

Yes, there will still be some men who think they have a right to women's bodies for sex and reproduction, and racism will double that. But with natural instincts restored, we will be able to stand up for ourselves, fight back, protect each other and our children, and reclaim our own bodies.

I bet that's where democracy begins.

DEBRA MESSING

Actor and Activist

Born 1968 in Brooklyn, NY

In 2005, a year after I gave birth to my son, I read a film script that was extraordinary. There was a supporting role, leading lady's sister, that I desperately wanted. I was told by my agent I couldn't get an audition. I said, "I can't get in the room?" I had countless best-actress nominations for *Will & Grace* and had a master's degree in acting from the prestigious NYU program. Being told they wouldn't let me in the room was humbling. I begged my agent to convince the casting people I wouldn't embarrass them. She prevailed.

I auditioned and I was happy with how it went. I was told it was between me and one other woman but that they were leaning toward the nameless actress. For the first time in my career, I decided to write a letter to the director and make the case for why he should choose me. To my astonishment, my letter was persuasive and I was given the role. The table read with the acclaimed director, Curtis Hanson (Oscar winner for *LA Confidential*, *8 Mile*, *Wonder Boys*), and actors Drew Barrymore, Eric Bana, Robert Duvall, and Robert Downey Jr. was thrilling. I was committed to doing my best and acting professionally and respectfully.

One of my scenes was a "love" scene where my sister walks in on me in bed with Eric Bana. The description was that my character was on top and all that was seen was my naked back. I felt comfortable with it. I don't know what possessed me, but I approached Curtis Hanson and said I wanted to be fully ready to film when I got on set, and I wanted to know if he was planning on shooting the scene in a different manner than what was written. He was jovial and said, "Oh, don't worry about it."

I said, "I'm not worried. I just want to come to set prepared."

He said, still very amiable, "We'll talk about it later." Each time I approached Curtis to have our little talk, he would say, "We'll talk later." We never did.

The day of the scene I came to set for rehearsal. Eric was a gentleman and Drew totally supportive. As the rehearsal proceeded, Curtis started making changes. He talked about me being naked, maybe getting up and turning toward camera. I was paralyzed. I couldn't believe what was happening. I went to talk to Curtis and he walked away. I went back to my little trailer where I was to get ready for hair and makeup. I called my manager and told her what was happening. I was so scared. She called my lawyer to look at my contract. I was told that I shouldn't worry because I hadn't signed a nudity waiver. I exhaled, then said, "What do I do now?" They said they would take care of it.

The next thing I know, Curtis is pounding on my door. I opened it, stunned, and he walked past me and slammed the door. "What is going on!" he screamed, visibly angry. I explained to him, in a stuttering, halting voice, that I hadn't agreed to be nude, and that I wasn't comfortable. He looked at me and spat out, with a disgusted sneer, "Do you know who I am? There are only three directors in all of Hollywood who get final-cut edit, and I AM ONE OF THEM."

I was speechless. I was sitting on the little upholstered bench and he was standing over me. I said nothing. He said, "Okay, so you'll let me shoot your naked back but not your naked ass?!"

I felt like I had to respond, so I said, "Well, I'm okay with the top of my hips being seen, ya know; the sheet can cover the rest of me. . . ."

He was losing patience. "Are you KIDDING ME? Okay, how far EXACTLY can I go down? SHOW ME."

I stood up, in my Juicy matching sweat suit, turned around, and put my hand on the lower part of my hip. I felt really, really uncomfortable.

He said, "No, SHOW ME. Pull down your pants and show me EXACTLY where I'm ALLOWED to frame."

I couldn't move. I just stared at him, in shock. I finally said, "You know, I don't feel comfortable. I'd like to call—"

And before I could finish, he stormed out and slammed the door. I called my manager and lawyer in tears. My manager told me to stay in the trailer, she was coming to set. I knew that Drew and Eric had been going through hair and makeup and were probably already in their wardrobe. I would be holding up the filming. The greatest sin for a new actress.

Finally my manager arrived and told me that she would take me home. I was terrified and traumatized. I felt I had done all that I could to prevent this from happening and now I was disrupting the shoot. I was worried Drew and Eric would be mad. But I knew that what was happening was wrong. So I packed up and walked to the parking lot. Drew ran over and I started repeating, "I'm sorry, I'm so sorry." And she made it clear that she was supporting me.

For the next few hours, my lawyer and the lawyer for the movie negotiated language that delineated exactly what I felt comfortable doing. It took hours, because Curtis was pushing back against any language. Finally, when they realized the scene would not be filmed without the language, it was approved. I returned and came to set to film. A crew guy came up to me and whispered, "Here, put fluorescent tape on your nipples. That way you are guaranteed your nipples won't end up in the movie." I will always be grateful to him.

Resisting.

ROSANNA ARQUETTE

Actor, Film Director, Producer, and Activist

Born 1959 in New York, NY

I met with Harvey Weinstein in the early '90s to discuss a role in the film *Romeo Is Bleeding*. We were to meet in a hotel bar, but upon my arrival, he insisted I come upstairs. It wasn't atypical to have professional meetings in a penthouse suite, especially with the most powerful man in Hollywood. Still, something didn't feel right. When I arrived, he opened the door in a bathrobe and exposed himself to me. As he grabbed my hand and moved it toward him, I pulled away.

"You're making a big mistake," he warned me.

"I'll never be that girl," I said, and ran to the elevator.

Soon after, jobs promised to me seemingly vanished. There were always vague excuses, and for a long time, I chalked it up to the nature of the industry. It wasn't until I compared notes with other actresses who'd had similar experiences with Weinstein that I knew he was behind it all. While I escaped the fate many women did at the hands of this serial predator, I hadn't escaped him blacklisting me. I continued to work, but that one meeting changed the trajectory of my career.

When Ronan Farrow reached out to me in 2017 and asked me to share my story, I knew I could trust him. He was compassionate and patient, so I agreed, and encouraged other women to confide in him. Despite the tremendous fear I had knowing what Rose McGowan had been through and the many journalists who were shut up and shut down, it was clear the truth had to come out.

The night before they released the story, I still didn't realize how life-altering it was going to be. The news spread like lava, as did the ramifications of outing the media mogul. When you are a public person, it hurts you in different ways. As the story gained momentum, I heard a voice that said, *No matter what happens, you are*

doing the right thing. I wasn't sure if it was my sister Alexis, but it was coming from somewhere outside of me. That's the voice you listen to.

Within a week, the news had sparked a widespread movement around the world. Droves of women in and outside the film industry came forward in solidarity naming their abusers. What began as whispers became a chorus of survivors saying, *Me too.*

As well-known white women like myself received the credit for igniting the #MeToo movement, I learned that an audacious woman named Tarana Burke had already created it twenty years ago, helping women in trauma from her basement. I remembered watching the Cosby women come forward and wondered why there was no backlash against him. When would the victim blaming end and sexual predators be held accountable in society and by our judicial system? But when movie stars speak, the media listens. It was the perfect storm, and finally, the pendulum swung in the opposite direction.

Telling my story was not my moment. My moment was stepping aside and giving Tarana the credit she deserves. My mother was an activist deeply involved in the civil rights movement. As a child, I marched alongside her and Martin Luther King Jr. That is where my roots are firmly planted.

My job is to support and amplify the #MeToo and Black Lives Matter movements. Strength carving out space for other women to be acknowledged. It is setting the record straight by saying, "Tarana did it first." We are stronger when we come together in sisterhood and solidarity.

Using my platform to shine a light on those who have been fighting the war on women and other marginalized groups is how I choose to effect change. Women like the Violence Intervention Program's executive director, Astrid Heger, who recognized child abuse as an epidemic and opened the center and understands trauma and what it does to a person's psyche. I joined Dr. Heger in creating the Alexis Project, a clinic in downtown LA that treats the LGBTQIA+ community, in honor of my sister, Alexis Arquette.

As an empath, people from around the world have shared their stories with me.

Women are the phoenix to the flame, standing up for what is right. I do this for myself, for my daughter, and for future generations of females. We are one in our trauma. It is a universal language and we are never going back to living a life of shame. Every voice matters. Every survivor deserves to be heard and believed, and to find their own path to recovery.

LYNZY LAB

Educator, Musician, Visual Artist, and Choreographer

Born 1986 in Texas City, TX

My moment came a little later in life than I'd like to admit. Growing up, I was the girl you'd always see drowning in her older brother's hand-me-down denim shorts and oversize T-shirts. I raced the boys. And fought the boys. And cracked jokes with the boys, often at the expense of the other girls in my class. So much of my identity was derived from the habits and mannerisms I'd picked up while being "one of the boys" that I didn't even realize I was gaining a false sense of empowerment. I was liked for being the cool, laid-back, uncomplicated, down-to-earth, funny, "not-like-other-girls" girl. And I took pride in that. And I used it as protection to shield myself from the sexism I saw displayed toward other young women my age on a daily basis. I was safe. I was not a victim. I was . . . wrong.

In retrospect, I believe it was that exact fallacy that kept me naive enough to think I was impervious to sexual assault. So when it happened to me on my bedroom floor at age sixteen, by an acquaintance of my brother's, I didn't even know that's what it was. I knew I felt violated. I knew I wasn't conscious for most of it and that I said no in the moments I *was* awake. But I didn't know it was assault. And I didn't know how to talk about it. Or if I even *should*. I spent the next few days suffering in silence while trying to piece together what I could remember, before finally breaking down and confiding in one of my closest girlfriends over dinner. "I think . . . I might have been date-raped."

She insisted I tell my parents. So I did. The police were called. A report was filed. But with an inconclusive rape kit (which was administered a couple days too late) and a fragile disposition, it didn't take much to convince me that it would be a waste of resources to press charges. So I didn't.

I found out a few years later that my abuser did the same thing to a couple of other young women, and the guilt I felt for not standing up and speaking out when I had the chance was a heavy burden to bear. I decided from that point on that I would spend the rest of my life advocating for myself and for other women and survivors of sexual assault.

In 2018, when Brett Kavanaugh was appointed a Supreme Court justice despite sexual assault allegations made against him a month prior, those same feelings of shame and guilt I'd been carrying with me for so long came bubbling to the surface and manifested in a tightness in my chest. It felt like a scream that had been trapped and needed to be released. But instead of screaming, I wrote a song called "A Scary Time (for Boys)."

KATHY NAJIMY

Actor, Comedian, Writer, Producer, and Activist

Born 1957 in San Diego, CA

I started gaining weight around the fourth grade. Around that time, it became really clear to me that boys and girls had strict rules on how they were "supposed to be." It also became clear that boys got the better gig. So I ate a lot of hummus and voluntarily took myself out of the dating game. Cuz it was no fair.

Even though as a teen I might not have had the right clothes or body or straight hair, when I turned sixteen, I found I *did* have two things to show the world. I discovered . . . my . . . BOOBS!!

So did Andre. And at sixteen, somewhere deep inside, I'm not sure how, I knew that Andre did not deserve me or the person I was soon to discover I was.

My best friend then was Lavonne. She was beautiful and thin, and she loved me because I was fun and *funny.*

Lavonne was dating Doug (who looked like James Taylor). One night we got invited to a party with the seniors. I ironed the shit out of my steel-wool hair and grabbed my Indian-print halter dress. Yep, my boobs were finally here and I was gonna present them to the twelfth-grade boys!

The party was at somebody's divorced mom's ugly San Diego condo. We walked in confidently chugging out of a bottle of cheap sugar wine. The basement was really smoky with two kinds of smoke . . . and loud.

Black Sabbath's "Elec-tric Fun-er-al!" blared from the turntable. Lavonne found Doug, and they were off to make out on the orange beanbag chair.

Then HE walked in: Andre Silva. Andre was a popular senior who was most known for two things: his impressive abundance of hair tucked under an orange cap and that he drove around in his uncle's pickup truck with "Silva's Mechanics"

proudly printed on both sides. He was kind of cute. He was exotic, with large, dark, French-like features and a sexy smile.

I saw him scanning the room. Most of the cute junior and senior girls were already coupled up, making out, or puking. But me and my double D's were standing in the kitchen doorway, forcing down cheap wine I pretended to like. I guess he figured this kinda fat, stacked tenth grader with questionable hair might be the last option.

He strutted right up to me and my rack. I seriously could not believe it.

We talked for a minute. He seemed shocked I had charm. Then he did that sitcom thing where he starts to talk to me looking in my eyes.

"So, uh, do you . . ." And then looks down to boobs—". . . wanna go for a ride?"

"In the truck??"

"Yep."

We got in. I hiked with both hands to get my short legs up and masked the grunt that hauled my butt into the seat with a high-pitched "WOW! This is cool!"

He pushed in an eight-track of Three Dog Night: "One is the loneliest number that you'll ever dooo."

Wow. He is actually talking and listening to me.

He pulls into the empty parking lot, the Kmart on El Cajon Boulevard.

We park in the dark lot, illuminated only by the big white *K*. His hand is on my thigh, tapping out the rhythm. Then he turns off the engine and immediately lunges in to kiss me. I cannot believe we are making out!!! I'm making out with Andre Silva, people!

He's smashing my mouth and jabbing his tongue in. It feels weird, but all I can think about is getting back to that party and telling Lavonne and everyone, "I made out with Andre Silva IN THE TRUCK!"

He's moaning, kissing me hard, and starts groping at my breasts, which are now way free of the halter. I kind of like the kissing and the boob stuff, but now *UFF!* His whole body is right on top of mine, pushing hard. I can hardly breathe. He's sweaty, heavy, and hot and reeks of Brass Monkey. I'm squashed in the passenger

seat. I torque my head and try to find some empty air space to breathe from. His entire body weight is on me, hard and humping, as he starts to lift—up—my—skirt.

Then it all comes to me in a flash. This is it? I'm sixteen and about to lose my virginity in a mechanic's pickup truck, in the parking lot of Kmart, to a guy who doesn't even know my name and whose hair is bigger than his head?

"Um. Stop," I say. "I don't think I want to do this right now, so maybe um . . . stop."

He's now wedged up against my door, pumping full on.

"No!" he says. "IT'S TOO LATE NOW. It's too late!"

I will never forget that phrase.

"IT'S TOO LATE!!"

I mean, I don't know! Was I gonna break his insides? Do boys have some physical thing that makes it impossible for them to stop? A muscle that once they start humping on a slutty fat girl they can't possibly stop without being paralyzed or having a heart attack or losing their penis or something?

"It's too late!!"

He shoves his Levi'd crotch on top of my underwear.

And then, in a moment of terrified, brilliant, unexplainable clarity, I drag my hand out from under him, reach the handle on my side of the truck door and—"Ahh-AHH!"

Andre drops out and *boom!* Slams onto the cement lot, with only his abundant hair softening the blow . . . and I just watch him . . . roll.

He wipes some blood off his forehead and doesn't say a word to me the entire awkward ride back to the party. Radio off. Silence. We arrive at the ugly condo. I reach for the truck cab's door handle—my savior—and get out.

I go in, pull Lavonne off a chair, grab a Fresca and a bag of Cheetos, adjust my breasts back into my halter, and walk home.

S. E. CUPP

Television Host, Political Commentator, Writer, and Journalist

Born 1979 in Carlsbad, CA

I was in my early thirties. I'd been in politics for a little while at this point, so I'd already been exposed to the particular brand of misogyny and vitriol reserved for young, right-of-center women. I was accustomed to the graphic rape fantasies both "fans" and trolls would email me. I was used to being trashed by other women who called me a failure and a traitor to my gender. It was tough to hear, but I could usually compartmentalize it to do my job.

Then Larry Flynt got in on the action. One night, while I sat on set at my show, a friend called to tell me I was in *Hustler*. After expressing my shock that he was an actual subscriber, I asked him to describe the picture to me. Uncomfortably, he said I just had to see it for myself. He took a picture with his phone and sent it to me.

There I was, my manicured hand holding a fully erect penis in my mouth, with semen dribbling down my chin.

Of course, it had been Photoshopped, with the appropriately blunt headline "Celebrity Fantasy: What Would S. E. Cupp Look Like with a Dick in Her Mouth?" In an accompanying explanation, it noted my conservative politics, saying, "Her hotness is diminished when she espouses dumb ideas."

I spiraled. I went in concentric circles of nausea and anger, nausea and anger.

You might wonder why an obviously fake photo—there was even a disclaimer published alongside it that read, "No such picture of S. E. Cupp actually exists"—would bother a person. I felt oddly violated. An image like that has a way of feeling true. I knew it wasn't, but I still felt dirty, ashamed. Had I done something to bring this on myself? Did I deserve it? Had I invited it?

I called my boss, my agent, my mother, my lawyer. I wanted someone to tell me how to make this go away. Of course, there wasn't a way. It was out there now. Forever. *Hustler* defended it against a wave of backlash from right and left corners, saying it was obviously satire.

So . . . I could let it bury me in self-doubt and self-pity, which was what they wanted, or I could decide they would not win. I went on various media outlets thanking *Hustler* for being so honest—most people who attack women for their views aren't as blunt and open about their intentions, which were in this case, to make me feel ashamed of my opinions. I congratulated the publication for refusing to cloak their rank misogyny in politeness, and vowed to carry on with my life as usual. It felt truly empowering to turn it on its head—no pun intended.

ROSANNE CASH

Musician, Songwriter, and Author

Born 1955 in Memphis, TN

He had his hands around my throat. I was seventeen. I had tried to break up with him, and his response was to show me that he could kill me if I tried to leave. In that moment, I had a searing, numinous impulse of self-preservation. I didn't move or struggle. I didn't beg him to stop. I didn't start to cry. I didn't say a word. I stood perfectly still and looked him in the eye with the stillness and contempt of every matriarch in my ancestral line back through the centuries who would have united to obliterate him for treating me like this.

He looked startled and let me go. I didn't try to break up with him again in person, but I waited until I knew I'd be safe. I turned eighteen, left town, and broke up with him on the phone.

It's useful information for a woman, and it's worth filing that self-counsel in the back of your mind, without letting it ruin healthy relationships: most men can break your wrist with a flick, crush you with one arm, hold you down, pin you against a wall, do anything they want. They have the physical advantage, and it's wise to just keep that as background knowledge, even if most of the time we are in the company of men who have evolved far beyond those violent impulses.

The moment of clarity, with his hands on my neck, was preceded by a terrible year of confusion, despair, and degradation. I don't know why I was drawn to him in the beginning. It was like being in a cult. In that year, I lost all confidence and sense of self-worth. But after I left, I slowly started to recover all those precious treasures of my own humanity. It took years. I drew on something bigger than myself to reclaim my own body and soul. I don't know if it was God or Goddess, the matriarchal ghosts or quantum physics, but whatever it was, I am grateful and whole at this moment because of that force, and I still rely on it.

PRIYANKA PATIL

Student

Born 1999 in Pune, India

I was fourteen. An after-school arts program offered for thirty kids from low-income communities in my city (Pune, India) was inexplicably changing my world. From being heard to being loved, this arts program was giving me what I was missing in my broken and angry household.

It was Diwali (a festival of light). My mother took me to meet my father, who was on a short medical leave. Grudgingly, I went along. After two hours of chatter, we prepared to leave, but he insisted that I stay. My mind started racing. Our arts program was doing a weeklong residential program starting the next day! We would be rehearsing for the musical we were opening in a month. I couldn't miss it!

I watched my mother leave, unable to stand up against my father's wishes. I spent the rest of the evening trying to convince him to let me go. That night I mysteriously gained the strength to speak up for myself. I asked my father, by what right, after never having been there for me, he could demand I forgo things that were important to me?

He didn't budge. What followed instead was a stream of threats.

Threat no. 1: You are not going back to your mother. I am sending you to the village.

Threat no. 2: You and your mother think you are free? Remember that I am still your father. I can come and clip your wings whenever I want to.

The last threat silenced me. His rage filled up the room. That night I sobbed after realizing my freedom was fleeting.

Next morning. Early dawn. I ran away before my father woke up. As the auspicious day began, something had dawned on me. Threats are one thing, but no one can take my freedom from me. I was ready to fight for myself.

TIFFANY MANN

Singer and Actress

Born 1987 in Fort Worth, TX

Even in this moment, as my fingers search for the next keystroke, I grapple with whether I should give a safe version of my answer. Do I focus on the struggles I think others can relate to? Will my mother be okay with it? Will people see me in a different light? But right now, I know that I can't serve anyone with a watered-down truth. So here it is in all of its bitter glory.

I was a considered a tomboy as a kid. All I wanted to do was climb trees and

play football. No cute dolls or tea sets for me. Give me the dirt, the grass, the mud! My mother always joked that I "sounded like five kids." It was just me playing dinosaur-rocket-train-dance-wars, a game I made up. I admit that those particular games could get a little loud; still, my mother would let me play. "Yay Tiffany!" was always her reply to my newest antics.

My mom became involved with this man. Let's call him Mark, 'cause that's easier, legally speaking. He battled with a lot of demons, and those battles would often spill over from the spiritual realm into my home. I remember waking up most mornings to broken glass, living room furniture askew . . . blood splatter on occasion. My mother emerging from the back bedroom with a new set of wounds. Somehow she always had a song in her heart. A tune on her lips. She tried her best to keep me from being afraid.

Admittedly, the specific timeline of the next events are a bit fuzzy, but the details are vividly etched in my memory.

Mark was on one of his rampages. It was probably about something as trivial as too much mustard on his sandwich. Who knows. I remember him lurching toward my mother, rage in his fists.

That. Was. The moment.

I was flooded with the strength of generations of ancestral wisdom. As I took flight, Mark could see that he was no longer looking into the eyes of a small child; he was facing a warrior. He froze mid-blow, overtaken by the courage that stood boldly before him. I fought for me. I fought for my mother and my sisters. I fought for my peace of mind. I fought for my continued safety. I fought for my future.

In many ways, I think that was the moment he no longer had a grasp on my

mother. After seeing the strength she instilled in me, and remembering her own, she left Mark.

One day while waiting for the city bus, midway through whatever loud game I was creating at the moment, I looked up at my mother. "I'm proud of you." Her warm eyes bathed me in a love only a mother could give. "Thank you," she said. A near-perfect blue sky framed her as she stood strong and proud.

A couple of Broadway stages, some fancy awards, a multitude of TV screens, and many loud creations later, I still carry the strength my mother gave me. I stand and fight boldly not only for myself, but for anyone who has yet to recognize the magnitude of their own strength.

TONYA PINKINS

Singer and Actress

Born 1962 in Chicago

My earliest childhood memories are of being held down naked and beaten across the buttocks and thighs with belts and extension cords or being bent over with my head squeezed between my mother's knees, suffocating in the folds of her polyester nightgown, knees buckling, crying, blind as she beat me across the back and buttocks. This was before I was five years old. I know because I remember the room where it happened.

We moved to a house when I was six. More space, less people, no less violence. Now I was expected to take off my clothes and lie on the bed and be beaten. Oh, and don't cry or "I'll give you something to cry for!"

By the time I was nine, I had had enough. I wanted to die. I didn't know how to commit suicide; aspirin didn't do it. So I decided to risk having her kill me. I was not going to lie down for another beating.

I don't know what I did or didn't do, said or didn't say, but she barked, "Get in there and take off your clothes so I can beat your behind." I walked into my room. And that is all that I did. When she came in, I was still standing fully clothed. "Didn't you hear what I said?" she yelled, extension cord swinging from her right hand.

She charged at me and I ran. I ran through my bedroom to my grandmother's room, around past the bathrooms, through the living room and the kitchen and down the stairs, past the back door and down into the basement. Now I was trapped.

I could hear her steps slowing down. She knew she had me. There was no need to rush. The burning salt tears welled behind my eyes, There was nowhere to go, nowhere to hide.

I heard her coming down the stairs. Sweat rose on my nine-year-old skin. I saw a brown beer bottle on a table. I grabbed it and slammed it across the table. Now I had a weapon.

She was fourteen years older than me, inches taller, and pounds heavier. I brandished my broken bottle. She stopped when she saw it. Was that a slight smirk on her face? She and I knew that she could overpower me. But she would get cut trying to do it.

She stood there awhile staring at me. Eyes burning. I could barely see through the tears streaming down my face. Her head was slightly bobbing. The brown cord hung limp, disappointed at not getting its taste of flesh.

Suddenly she turned and walked away, up the stairs, and into the house. I collapsed on the sofa still gripping the bottle. I stayed down there all night.

She never again told me to lay down and take a whupping. From then on it was random slaps and punches that came out of nowhere.

My moment began that night at nine years old, when I refused to be complicit in my own abuse. And now I can bless my mother for all that she put me through. It made me strong. Nothing and no one can scare me. There are lots of people with more power and weaponry, but I know that if they try to hurt me, it will cost them. My moment was the refusal to bow to my mother's will over my own. I bless my mother for the gift of my own sovereignty.

ALLISON RUSSELL

Singer-Songwriter and Activist

Born 1979 in Montreal, Quebec

The Moment(s) I Realized I Was Ready to Fight for Myself . . .
Jubilee we're free
Free to fight for our equal
full humanity
each moment a chance
to stand for ourselves, our kin
for ev'ry born child
we are more than seeds
we're the soil and the water
the good ancestors

I used to wish that I'd been raised by wolves, instead of by white supremacists. I dreamed of running wild through the woods, at ease in my own skin, strong and fast and free. . . . My reality was unbearable, and so I learned to leave my body—to live deep inside my own imagination, inside books, inside music, inside fantasy. I learned to hide. Hide under the piano to try to hear my mother's heart as she played, without drawing her wrath. Hide on the astral plane, to try to turn into a supernova and dissolve into boundless light while my adoptive father tore my little body apart.

He called himself my father, but he was really a jackal in disguise. The thief of my childhood, my tormenter, my abuser. He told me that even my own mother didn't love me, that my black skin was a curse, that I was hideous, worth less, less than human—not even three fifths. That I was lucky to have him to "take care of

me," because he was the only person in this world who would ever "love" me, un-lovable as I was. He told me this story for ten years. I believed it. He poisoned my mind and broke my body. He called it love, what he did—but I knew it wasn't—even at five years old. I thought I deserved it, though. I didn't think that I was someone worth fighting for. I just wanted to disappear.

I might have died had my baby brother not been born, when I was six and three quarters. My childlike mother didn't want another child but the Jackal forced her to have one. Throughout the pregnancy she was furious, despairing, in and out of the frightening, full-blown psychosis that was a symptom of her then-undiagnosed schizophrenia. I sang to the taut, low-riding mound of her belly while she slept. I wanted the baby to know there was someone waiting on the other side who loved him.

After my brother was born, my mother fell into a prolonged postpartum depression. I fell deeper in love with the baby. I did everything I could to shield him from our family's violent dysfunction. I changed his diapers, gave him baths, made sure my mother nursed him regularly. I held him through his colic and I sang him to sleep. As he got older I would read to him. I made up songs and stories and plays, to distract him from our parents' storms. We spent hours at the park. I discovered that my imagination was powerful enough to transport us both. I made sure the Jackal never hit him; I shielded him with my body. In loving and protecting my baby brother, I began to learn how to love myself. I was good for something more than rape after all. In fighting for my brother's safety, I began to understand I would have to fight for my own.

When I was fourteen my infant niece and nephew, the children of the Jackal's firstborn son—from his first marriage—came to live with us. I stayed home from school that year, the ninth grade, and became their full-time caregiver. They slept in my bed with me, and for the first time in my life, I felt safe at night. When they went back to their father, I knew I could no longer live with what the Jackal was doing to me.

I broke my own heart and my baby brother's when I ran away from home at

fifteen. I had no choice. This was the precipice. Fight for myself and run—or die. It was safer for me to sleep in the Mount Royal cemetery than to stay one more night with my family. I could not take my eight-year-old brother with me. Leaving him behind was a nightmare that lasted for five years. He was almost fifteen when the Jackal went to prison after I brought charges against him and I became my brother's guardian at twenty-one.

Every day since then has been a series of moments where I have to choose—to fight for myself, for the ones I love, for the ones I've never met and never will, for the possibility of a thriving existence for all the future generations on this Good Earth. I was saved by love for my brother, love for my niece and nephew, and by extension slow-growing love for myself. I was saved by the Activism of my Imagination, by the Transmogrification of Trauma into Art. Saved by the Chosen Family and the expansive community of creative people I eventually found.

When I gave birth to my daughter, Ida Maeve, seven years ago, I felt connected to every woman, every person, every mother who ever cried out in terror and wonder at the transformative sacred Mystery in all its fearful majesty, gore, and uncertainty. I stepped into the stream of ancestors to be. . . . I want to be a Good One—with all my heart, with all I've got. Since Ida chose me as her mom I've felt an urgency to stop my habit of hiding, lest I pass it on. I fight for the dream of equality. I choose to fight and speak and sing in spite of shame, my constant companion. I want to end the insidious, ubiquitous pandemics of bigotry, abuse, and violence. These intergenerational traumas, these cycles of violence flourish with our silence. I will never shut up or hide again.

Survivors, standing at the intersection of the margins, have the clearest view of

the page. Our vision is needed. Our stories, told in our own words, in our own names, can save lives. Alice Walker said it best: "We are the ones we have been waiting for."

I believe in us.

With love, hope, forgiveness, empathy, compassion, patience, truth, and resilience, we rise. Again and again.

RABIA CHAUDRY

Attorney, Advocate, and Author

Born 1974 in Lahore, Pakistan

The moment in my life when I knew I was ready to fight for myself was the night I left an abusive marriage and was forced to leave my four-year-old daughter behind with her father. I was in court two days later, fought for eight months to get custody, and ultimately won. But the night I left, something in me changed. I had cried for years, but the tears suddenly stopped that night. I just got this steely determination that no matter what, I was leaving him and getting my daughter back. And I didn't shed a tear until I did. That prepared me for single motherhood and many, many challenges I faced in later years.

ZOSIA MAMET

Actress and Musician

Born 1988 in Randolph, VT

Anorexia has the highest mortality rate of any mental illness. Which to me means anyone who survives it is a fucking warrior. I don't say this to toot my own horn but rather to put into perspective what a monster of a disease it is. It is manipulative and pervasive and fucking smart. And for anyone who has suffered or is suffering from anorexia or any eating disorder, I am so sorry. Mine started when I was eight and lasted—well, I should say will last—for the rest of my life. The reality with addiction is that you're always recovering. But there was a time when I was a slave to it and now I'm not. But this didn't happen overnight. I have fought this battle SLOWLY, since I was eight. It got worse before it got better, I had setbacks and relapses. It wasn't a straight or easy path.

The summer I was fifteen I would ration one apple as my entire food for the day. A few years later I stopped drinking water entirely because it added to my weight on the scale. When I was seventeen I told my therapist I'd be happy if I could just hit a hundred pounds. I hit ninety-nine but still couldn't stop starving myself. I used to run so long and hard after a "meal" that my legs would cramp up and I would walk home crying in pain. I had no period and no sex drive, and I cringed at my reflection. I hated myself.

Thankfully, today this isn't my life. I'm no longer ruled by my disease. This doesn't mean I'm entirely free of it. But right now, I am winning. Not just winning, I am dominating. It's been gradual. I've spent the majority of my life fighting to silence what my old therapist used to call "the bitchy roommate who lives inside your head." And I have, mostly. I am happy, I am strong, I am in a loving marriage. I eat intuitively. I don't use exercise as punishment. I don't starve

myself or weigh myself, which are two things teenage me couldn't even imagine. I didn't notice the miles I had traveled away from my sickness until there was enough distance that I could look back. Sometimes you have to get far enough away from something to realize its magnitude. You have to climb to the top of the mountain and look down to see how far you've come. This entire twenty-four-year battle has been me fighting for myself.

But I suppose the tipping point was a certain doctor's appointment. I was seventeen. I weighed eighty-nine pounds. The doctor told me if I continued at my current rate of starvation I would die. I was so gripped by my disorder that the words barely sank in. But I remember leaving that appointment and thinking, *I know I don't want to die.* Just by thinking that thought my fight began, because in that moment I chose myself over my anorexia for the first time.

It's much easier now than it was at seventeen or twenty-two or even twenty-eight. It continues to get easier but I keep fighting. I tried to evict the bitchy roommate, but she claimed squatter's rights. She gets a little loud from time to time, but for the most part I just ignore her. And at the end of the day, I'm still here. So I think it's pretty clear who won this round. Never stop fighting for yourself, no matter what form that takes. Choose you, choose life, choose happiness. You're worth fighting for.

STEPHANIE YEBOAH

Author, Content Creator, Advocate, and Journalist

Born 1989 in London

The moment I knew I had to show up and fight for myself was in May 2013. It was my birthday week, and I had locked myself in a bathroom and was staring at my bikini-adorned body in the mirror for over twenty minutes, meticulously obsessing over loose skin, stretch marks, rolls, and folds. My mental health was the lowest it had ever been, and I realized there and then that I needed to learn to show up for myself and not let the depression win.

I've been fat my whole life. As a child, I was mildly chubby, and as I progressed through secondary school, college, and university, my weight steadily increased, much to my dismay and to the delight of school bullies. As a result of this, I was diagnosed with clinical depression and took to frequently self-harming in a bid to deal with my crippling body insecurities, low self-esteem, and low confidence. I absolutely hated myself.

After graduating university, I decided that enough was enough and so I started to work out five times a week and eat healthier; however, the weight wasn't dropping off as I thought it would. I started skipping meals. I bought dodgy diet pills from foreign websites in an attempt to suppress my appetite. I joined liquid-only dieting clubs and I started throwing up after eating. For two years I lived with a full-blown eating disorder but, due to my being fat, my weight loss was encouraged and applauded instead of seen as an issue or cause for concern. My missed meals and food purging were apparently signs of me "doing what was best for my fat body!" as opposed to being seen as abusive behavior.

I kept this up for years, and decided to accelerate the process four months before my birthday. At the time, I had decided to go on a beach holiday alone as a

treat, and bought a bikini several sizes too small as motivation for myself to lose weight. I gave myself four months to lose 120 pounds and through my disordered eating, I accomplished it. Cut to me in my hotel bathroom in Barcelona, staring at my tired, sullen, abused body. I'd finally gotten the body I thought I needed to have, but at what cost?

The whole ordeal took a toll on my mental health, particularly my confidence and self-esteem. I had assumed that I would feel a lot better about myself and how I looked once I'd lost the weight; however, I ended up feeling more insecure, and worse than I did when I was bigger. Due to the disordered eating, I had damaged my stomach, my mouth, and my throat. I had starved and abused my body in a bid to look the way society wanted me to look and yet . . . my body refused to give up on me. After everything I had put it through, it was still here, keeping me alive. At that point, I decided that I needed to learn how to fall in love with me, how to fall in love with my body, and how to be content in the fat body I'm in.

I had to unlearn all of the toxic, fat-phobic behavior I had been taught by society. I had to erect boundaries to friends and family whenever the topic of weight came up. I had to learn how to not base my self-worth on my physical appearance, or how men viewed me.

I had to learn to see my body as home, and to fight and defend it at all costs.

MALLORY MANNING

Detective and Former Lifter

Born 1987 in Little Rock, AR

I was twenty-nine years old and weighed 350 pounds when a friend of mine, who happened to be a fitness trainer, told me bluntly that I was morbidly obese and that I was very close to needing help just to get around.

Even though I knew I'd let myself go, I was sort of stunned that he said that to me. But I slipped back into denial because that's what I'd always done. Still, his words quietly echoed in my head, and a few months later, when I saw a picture of myself as a bridesmaid in a girlfriend's wedding photo . . . it hit me. I knew then that I was in trouble. That was my moment.

I finally saw, for real, what my friend and what everyone else saw. I had started diets so many times over the years, but I'd always ended up quitting when it became too hard or I wasn't getting the results I wanted.

But not this time. This time, it was different. I knew if I didn't do it then, I might not make it. Something clicked.

So I fought. Hard.

I reached down deep and I discovered willpower and strength that I never knew I had. I was a woman on a mission and I finally found the fighter in me.

I have found the career that I am made for—police work. And I've developed a true passion for lifting weights and showing just how strong I can be.

I became determined to make myself proud and I can honestly say that I have. Yes, I lost a lot of weight, but what I gained was so much self-confidence.

But the most important thing is, I found love for myself that I'd never really had before.

I finally love ME.

RICKI LAKE

Actor, Television Presenter, and Producer

Born 1968 in Hastings-on-Hudson, NY

There have been many times when I have stood up for myself. What comes to mind now happened just six months ago. I told my truth about something so personal and painful for me. I had been plagued with this secret off and on for twenty-five years. I was dealing with significant hair loss and it was paralyzing me in many aspects of my day-to-day life. I turned down jobs because I didn't want anyone to know that I was wearing a hairpiece/extensions. I didn't want strangers touching my head and knowing my secret. I felt unattractive and ugly. It physically hurt. The extension piece I wore pulled my fragile hairs that I had left on my head. I didn't want my partner to touch my hair ever. I couldn't swim or get my hair wet. NO dips in the sea. Showering was a traumatic experience.

Coming out was the single most courageous thing I have done in my life. It was a time when I truly stood up for myself and spoke my truth. I had to. I felt I didn't have a choice. I shaved my head for all the world to see. I was at my breaking point and didn't care about the potential negative reactions. It was liberating. I had always considered myself an authentic and open person. I had almost nothing to hide, except maybe my weight. ;) This was the ultimate example of keeping it real. I had no interest in wearing wigs for the rest of my days. They were hot and hurt my sensitive scalp. By facing my darkest fear and surrendering, I was able to truly accept myself and feel tremendous pride for who I am. Unbeknownst to me, there were countless women and men who not only could relate but also supported me during this transition. I felt free, I felt loved, and I felt that I can overcome just about anything.

LAUREN BLITZER

Music Business Executive, Author, and Activist

Born 1981 in New York, NY

Working as a sales assistant at *Teen Vogue* was my first real job after graduating from NYU. It was 2004 and landing a gig at 4 Times Square was incredibly competitive, and I had apparently won the prize. In fact, it was an unspoken rule not to ever speak or look directly at Anna Wintour if ever in the same elevator or in her presence. I swear to God, that was a real thing.

We were all instructed to want to be like this woman, whom I had no desire to emulate. Be stylish, be elitist, join the clickity-clack of the same designer heels in the lobby every morning. I was not like them and I wasn't sure if being different was okay—if being gay was okay.

While it was only a short-lived trauma, my family had had trouble dealing with my big announcement and it left me feeling more thin-skinned than I thought was humanly possible. I was scared of being rejected, judged, and dismissed because of something I could not control or deny.

At the time, I didn't know one woman in my industry who was gay, let alone out. I had told only my best friend at work, my fellow sales assistant, also named Lauren. Her response was something like, "Duh. I mean sorry, I kind of knew," which was nothing short of a relief.

It was my birthday and my girlfriend at the time had sent me flowers. She knew I wasn't out at work, so she signed the card "A.G." My cubicle was small and impossible not to pass. The huge bouquet sat on my desk garnering more attention than I ever wanted. While I loved the gesture, I hated what it meant. Questions. Lots of questions.

I remember how I felt like it was yesterday.

My boss, who was young, hysterical, and just fun to be around, decided to take me with her to a few sales meetings that day. It wasn't something she was required to do, but she wanted to teach me more than I would ever learn taking messages (mostly incorrectly) at my desk.

She had seen the flowers earlier and on our way out the door she said, "So what's his name? I saw the card. Who is A.G. and do you love him, too?"

I avoided her questions by laughing and pretending to be shy. All day she kept asking me, "Come on, tell me, is it Andrew Goldberg . . . Alan Grant . . . no wait, Adam Gilbert." It went on and on. I kept saying no and laughing.

All day I fought with myself internally. I would go from beating myself up about not being honest to convincing myself to just get through the day, they would forget about this tomorrow. Then scolding myself for hiding who I was. It went on all day. Every time I thought about telling my boss, my heart would start to race and my face would get red. The words *would not* come out.

It was almost five o'clock and we were back at the office. I got to my desk as she came over one last time, touching the lilac that hung over the vase, and said, "Fine, I give up, I'll leave you alone," and that was the moment I decided I wasn't going to deny who I was.

"Ali, it's not a guy. Her name is Allison Grover. That's A.G.," I said. "I'm gay."

She was surprised but not upset or disappointed or disgusted. She'd simply been wrong about me.

"Well, why didn't you just say so?" she said, smiling.

That was the first of hundreds of times I would have to come out in my daily life. After I had kids it only got worse; people would just assume if there are children, then there is a man. "What does your husband do?" I would get a lot. My answer: "I have no idea, but my wife is a musician."

YVETTE BURTON

PhD, Educator, Strategist, and Advocate

Born 1966 in New York, NY

There's only one thing more daunting than leaving the safety of your parents' home for college: returning home a different person than they remember or find familiar.

By the end of my freshman year at the University of Tampa, I was so ready to return to my home city of New York. Reconnecting with family was something I'd romanticized for the past ten months of trying to live in and understand race relations in the South. At the same time, my family seemed so very disconnected from the life I'd built on campus. That semester I realized I was attracted to women and enjoyed college life surrounded by new friends and select faculty who supported me as I came into owning and living my truths.

When my plane landed at Newark Airport, I felt the knot in my stomach worsen. I was fifteen minutes from the gate and thirty minutes away from hugging my parents hello, and facing a two-hour car ride spent trying to avoid my mom's usual drills of "Who are you dating?" questions. My mother's Southern Baptist up-bringing was central in her life and making sure I abstained from premarital sex with boys was her core concern.

As a Black woman raised in rural Virginia during the 1940s, she was proud of how our family had survived and thrived over the years. Her mother (my nana) grew up in the post-Reconstruction era and was raised with the mindset of personal responsibility to honor our ancestors who sacrificed so that we might thrive. I was happier about my personal contribution to our family's story than I was about becoming the first family member to graduate with a four-year degree.

Although I made it home from the airport without any awkward or loaded discussions, I still felt anxious knowing the conversation about dating and virginity

had to happen before I returned to the airport. As I unpacked the last of my travel bags and settled into my old room, my mother knocked on the door and threw down a crumpled letter from a yellow notepad. When I unfolded the letter, I realized it was an early draft of a note I was helping a gay male friend write to a classmate he wanted to date. My mom knew it was a letter from one man to another, and she knew it was my handwriting.

"This is disgusting, Yvette! If you hang around people who live like this, people will think that you are one of them." I can't say that I remember much of what she said next. My mother was a big believer in spankings when I was younger, and direct eye contact at a moment like this meant certain peril. I thought gazing off into the distance in silence would be the best way to deescalate her anger.

"You act as though you are okay with all of this. Why are you okay with this?" she yelled. "The next thing you're going to tell me is you are gay." Although I felt like a dog trapped in a corner, I looked directly at her and said, "Well, now that you mention it, I am gay too."

It was as though I pulled out a gun and aimed at her heart. She said that I had "picked this gay thing up in Florida," and that I'd never been quite the same since my eighth-grade boyfriend broke up with me. My mom continued yelling and explaining that she was ashamed of me. I was an embarrassment to the family dead and living. My father and brother joined the screaming and added that I had changed since I left for school and not for the better. I stayed silent as my dad and brother accused me of causing trouble at home. I was "selling my ancestors and turning on my family."

One hour into the argument, my mom repeatedly asked me to promise that I was "at least bisexual" so that she could experience being a grandmother. I told her I couldn't make that promise and would never lie about something so important. As I listened to the three of them pointing, shouting, and attacking who I was, I knew this argument was more than a family spat. Somehow this had turned into a defining moment. My family had given me an ultimatum. "If you want to stay in this house, you will abide by our rules." I told them I could not live a lie and I would make other arrangements, which fueled my parents' anger even more. "Go ahead,

call your freak friends to help you, get out. You'll never be welcomed back in this house again." Fueled by anger more than courage, I walked past my parents and called a local group of friends I'd met at the State University of New York at Stony Brook Lesbian and Gay Student Association. My friends could barely make out what I was saying through the tears. I begged them to pick me up, although I had nowhere to go.

Fifteen minutes later, a car full of my friends met me at the end of my parents' driveway. I collected my belongings and hastily stuffed them into black garbage bags. Although I did not want to leave, I knew I couldn't stay. Staying would mean leaving the woman I'd fought to become. It killed me to watch my mom, dad, and brother turn their backs on me. But what crushed me was the sight of Nana waving and blowing kisses to me through the window blinds as we drove away. Nana was love, acceptance, and my light.

I slept in a car until I was able to obtain housing at Stony Brook. Mom and Dad passed away, but not before we reconciled. Later I learned that the painful moment of leaving my family's house was the moment they met the grown-up version of the little girl they'd always loved. It was the moment I was made for.

MONA MORIYA

Arts Administrator

Born 1995 in Los Angeles, CA

The M train creaked as it trudged above my beloved, bustling Brooklyn. Butterflies in my stomach, I texted, *Running late—6:30 okay?*

It was a chilly night in April, my first night out in the city. My best friend, Rob, was here to help, both of us overworked and underpaid at our internships. Wearing ripped skinny jeans and a much-too-thin leather jacket, I was going to meet Samantha.

Teeth chattering, Rob and I waited in line to squeeze into a packed and sweaty Cubbyhole, the famed lesbian bar in the West Village. Music blasting and decorations exploding from the ceilings couldn't keep my eyes from landing on Samantha. She was standing among a group of women, all of them confident and carefree. Mustering up some courage, I walked over. Conversation flowed and midnight soon turned into 3 a.m., Wait, where did Rob go?

With the intent of entering a casual summer fling, I soon found myself falling for the first woman I had ever dated and realized that lesbians don't do "casual." All the butterflies people talked about finally made sense. But from day one, Samantha was set to attend grad school in Boston come fall.

When I met Samantha, she was twenty-six and in the closet. The only child of Chinese immigrants, she had yet to come out to her parents, and with me being the only daughter of Japanese immigrants, I understood. After years of reducing my attraction to women as "girl crushes," my summer with Samantha was one of the most enlightening experiences of my little life.

That summer flew by and my relationship with Samantha came to a halt once she left New York for Boston.

155

Six months later: I hopped off the M train and ran to my Bushwick apartment rooftop. Out of breath, I called Samantha. After some agonizing small talk, I blurted out:

"I feel like I was a source of shame for you."

Silence.

"I'm sorry. What?"

"I feel like you were ashamed of me."

"You wouldn't understand. Working in law, it's different."

"So you're just never going to come out?"

"It's not shame, it's *cautiousness*."

When Samantha moved to Boston, she began drifting away from me. Phone dates canceled, texts unanswered, and I soon learned she was hiding her sexuality from her peers. Desperate to make the relationship work, I ignored all the signs. She would become tense and uncomfortable when I mentioned visiting her on weekends, and I optimistically hoped it was merely because she was swamped with schoolwork.

Finding that same courage I'd had the night I met her, I responded:

"I've decided to come out to my parents this Christmas."

"Wow, Mona. That's really great. I hope it goes well for you."

"I hope so too."

The phone clicked. The sun had set. It was dark; I was alone. And for the first time in a long time, I felt relieved.

I wasn't going to have to be anyone's secret anymore.

LENA WAITHE

Screenwriter, Producer, and Actor

Born 1984 in Chicago

Coming out was a big deal for me. I no longer wanted to be dishonest about who I was. So I stood up and told my truth and I haven't looked back.

CHELY WRIGHT

Singer-Songwriter, Author, Advocate, and DE&I Executive

Born 1970 in Kansas City, MO

I retrieved the gun from the top shelf of my master bedroom closet. It was wrapped in a white kitchen towel that had, over time, become dingy with age and spotted with cleaning solvent. I removed the towel and held the heavier-than-I'd-ever-realized chunk of steel and aluminum in my right hand. As I slowly made my way down three flights of stairs, I handled it as if it were a cross between a dirty diaper and an improvised explosive device. If it's possible to hold something loosely and firmly at the same time, that's what I was doing. Once I reached the first floor, I disengaged the safety mechanism, then set it down on the mantel of the coal-burning fireplace in the foyer of my historic East Nashville home. I felt like I was watching a movie. A scary one.

I stared at it for maybe a minute. Then I picked it up again.

Fifteen years earlier, I lived on the second floor of a two-story apartment building with exterior entry access. This was in a not-so-great part of Nashville, so I felt lucky to find a parking spot in front of my breezeway that night.

My 1989 Chevy Corsica was the newest car I'd ever owned, and I felt safer in it than in my previous car, which didn't have a functioning driver's-side door lock. I put the strap of my purse over my right shoulder and, as always, I got the key to my apartment ready to go—pinching it between my thumb and my index finger.

I exited the car, then climbed the industrial steel staircase to the top. Since moving into the apartment, getting my key to work had always been an ordeal. I'd even asked the landlord if I could have a new key and she'd said, "You just have to play with it," which is what I'd learned to do.

I was just about to put my key in the lock when I heard a shout, "Hey!" I looked

down and saw a man at the bottom of the stairs, staring directly at me. Our eye contact seemed to last for a long time, even though I know it didn't. What scared me most was that he didn't look angry, but instead his eyes seemed to communicate regret, as if to say, *Sorry I'm about to attack you, but I'm attacking someone tonight and I guess it's going to be you.*

What happened next has played in my mind for thirty years. Some details have always been blurry and some crystal clear. Some play in slow motion and some in fast forward.

After he bolted up the staircase, he grabbed at me and the weight of his pull on my purse threw me off-balance. He then dragged me halfway down the stairs to a landing. I heard my parents' voices in my head, barking out a command they'd instilled in their two daughters: *Kick him in the balls!*

He was behind me with his arms wrapped around my upper shoulders, so I couldn't kick him. There was no space between us, and we sort of became one unit. Where he went, I was bound to go. I saw my purse with its broken strap on one of the stairs. This was more than a robbery. I knew I was in trouble.

There was a wooded area just a few feet behind my car. I'd always been nervous to come and go at night because anyone could be hiding in there, ready to pounce. When I realized he was probably going to drag me into that area, my brain shifted into some sort of high-torque, crisis-management gear.

My inner voice said, *You're going to die if you don't take control of this situation. Get your head on straight and make a plan.*

In that instant, I became hyperaware but freakishly calm as I took inventory of every detail, knowing my strategy would matter. The stench of him, the noises he was making in my ear, my own breathing and that his body—while shorter than mine—seemed to be made of solid muscle.

Suddenly, one of his arms let go for a second and I wondered if I could spin around and "kick him in the balls!" Nope. As quickly as his arm had released, he reclaimed his grasp of me. When he did, I saw the knife cross in front of my face as he continued to try to pull me down the stairs.

Because I'd found my center of gravity, he was less able to move me around and I began to sense *his* panic. He held the knife out in front of my face and shook it, which released his hold on me again, and I seized the opportunity.

My inventory, just seconds before, had reminded me that the key to my apartment was still between my thumb and my index finger. I had a weapon too. I swung my arm up and across my body to his face, which was pressed against my left ear.

I felt my finger and my key plunge into something wet. He let go. I leapt up the stairs to my apartment. At first, I thought I'd gotten him in the mouth, but as I looked back, I saw that I'd landed a blow to his eye. With both hands covering one side of his face, he screamed, "BITCH!"

I thrust my hand in the direction of the lock, and that key, which had always been so tricky, went right into the hole. I got into the apartment, threw the deadbolt, called my best friend and then the police.

A couple of days after it happened, my parents drove all night from Kansas to check on me and they brought with them a 9mm gun—to keep me safe.

Fifteen years later, I'm not sure how long I stood there with the gun in and out of my mouth, watching myself in the century-old mirror built into the mantel of the fireplace in the foyer. I'd pick it up, put the end of it between my lips, place my thumb on the trigger, imagine the next steps, and then put it back down. Then the emotional dam broke. Tears, hyperventilating, screams of anger, shaking, and nausea overtook me.

My secret twelve-year relationship with the woman I loved had fallen apart. I'd blown it up by making the choice to try to protect the career I'd built instead of putting a premium on my well-being and happiness. That was the beginning of a cascading effect, wherein a series of negative events just piled on top of one another.

I was a product of Nashville's Music Row. No one in commercial country music had ever publicly acknowledged being gay, and it was understood that the industry and the fans would not be okay with it. To come out at that point would

be to admit that I'd been lying about so many things. Being known as an honest person with integrity was important to me. I took pride in my reputation. So to admit that I hadn't been truthful about something so big would be humiliating. I knew what I'd signed up for in country music. I *couldn't* come out. I was trapped.

That same 9mm gun my parents had delivered to me all those years before—for my protection—was about to be the instrument of my death.

Just to be clear, I wasn't going to end my life because I'm gay. I was about to end my life because I was tired: spiritually, physically, and emotionally. I'd spent so many years hiding the fact that I'm gay and I'd hit my rock bottom.

I set down the gun, went upstairs, crawled into bed, and continued falling apart until somehow, I fell asleep. When I awakened a few hours later, it was still dark outside. I wasn't sure I wouldn't make a beeline downstairs to that gun to finish myself off. I knew I was in trouble. So, I did something I hadn't done in a long time. Prayer is a regular part of my life, but getting down on my knees to pray was something I hadn't done since I was a kid.

Most of my other prayers in life included my asking God to either make me *not gay* or to help me keep my secret. Instead, a new prayer came from of my mouth. I said aloud, "Dear God, if you've got a way for me, I need to know it now. In your name I pray, amen."

And much as it happened all those years before on that steel staircase, I heard my inner voice say, *You're going to die if you don't take control of this situation. Get your head on straight and make a plan.*

That was the moment that I realized I was ready to fight for myself. That was the moment I knew that I had to come out of the closet. And once again, I knew my strategy would matter.

In the months that followed, I paused a hundred times at that mirror, and even though I could still sort of see my reflection holding that gun, I knew I had a way out of the darkness. I wore a path from that spot in front of the fireplace to my dining room table where I sat for months, writing my coming-out memoir, *Like Me*.

And just as it happened all those years before, my saving grace was when I realized that the key to my survival was right there—at my fingertips—the whole time.

Writing and sharing my story became my superpower.

MARY-MITCHELL CAMPBELL

Conductor, Music Director, Orchestrator, Composer, and Arranger

Born 1977 in Wilson, NC

When I was sixteen, I attended the Governor's School of North Carolina summer program in Winston-Salem and had my first experience of being on my own. Coming from a challenging home situation marked by mental illness, it was liberating in ways I never could have imagined.

I met people who were vastly different from my classmates from home and we talked about philosophy, art, music, religion, and the meanings of life underneath the stars of the Salem College campus.

Halfway through the six-week program, I knew I couldn't go back. I learned that the school across the street—University of North Carolina School of the Arts—was a high school as well as a college and I marched over to speak to someone in admissions.

"I'd like to go to high school here as a piano major."

"Excellent, we have several audition dates throughout the year. Here is a pamphlet, and you can call to set up an audition for later this year."

"No, I would like to come this fall. Are there any last-minute openings?"

"Oh! Well, that is highly unusual. Let me check. . . . Actually, we could see you the day after tomorrow at two p.m., if you are ready to audition immediately."

"Yes! I'll be ready! Thank you."

I quickly threw together an audition. I was extremely nervous, but also incredibly determined. I could feel the importance of this opportunity. I confidently walked in two days later and performed, even though my heart was in my throat. I was ready to fight for a different future.

Three months later, I was a full-time student and saw a performance of a musical where I knew I wanted to conduct Broadway shows.

BEANIE FELDSTEIN

Actor and Singer

Born 1993 in Los Angeles, CA

It was the summer of 2008 and I was attending my fourth summer at my beloved theater camp, the place that made me believe in magic. It was a dream: campers constantly gathered around the piano belting Sondheim lyrics and no sports! Truly heaven for my teenage self (or my adult self, honestly). My first summers, I was cast as small supporting roles in "the kiddie show," the show loosely designated for the youngest campers and performed on the smallest stage. My third summer, I was in the ensemble of *Jesus Christ Superstar* with the older kids in the outdoor theater, which felt like a solid level up. But I arrived for my fourth summer determined to show them what I was made of and finally land a main role on one the bigger stages. I was fifteen now and I had trained so hard during the year to improve—I was ready!

So on the third day of camp, when the cast lists were posted, I scurried over to find my name. Would I be in *Fiddler on the Roof* or *Rent* or maybe just maybe the most coveted show of the session: *The Producers*? Our camp would be presenting the first nonprofessional production of the show *ever*. Everyone was buzzing about it. I scanned all the cast lists until finally I landed at the show *A . . . My Name Is Alice*, an all-female musical revue on the smallest stage. Now, at twenty-seven years old, looking back, I think it would be so amazing to do an all-female revue where everyone was equal and you created something truly as a team. But at fifteen . . . I was livid and heartbroken. I had been tossed to the smallest stage, which felt like a huge a step back. I felt like they just didn't see me or the work I had put in. I was devastated.

I thought I would run up to my bunk bed or bury myself in my best friend's shoulder. Or just stand in that spot and let the tears fall. But instead, something

shifted. Something rattled inside my tummy, growing in size by the second. Without knowing what I was doing, I turned on my heels and marched into the office to see the infamous K. K was the gatekeeper, the woman who had made every single casting decision at the camp for decades. No one took on K. But somehow, my legs were moving. I stomped directly up to her desk, crossed my arms, and made her meet my eyes. When she begrudgingly did, I held eye contact and stated clearly: "I want to be in *The Producers*." K sighed, "No, Beanie. *The Producers* is a closed cast. The director handpicked every single person he wanted to be in it and he won't make room for anyone. This is the show of the session. It's not going to happen." I

took a deep breath, dug down deep, and finally two words slithered out through clenched teeth: "Ask him."

Two hours later, I got pulled out of *A . . . My Name Is Alice* rehearsal and told to go to Studio E, where I would be joining the cast of *The Producers*. I bounded in and the director pulled me aside and whispered in my ear with a smile, "I am *so* thrilled you're here. Let's have some fun with this one."

I fought for myself. I fought for the work I had put in year after year. I fought for my growth. And after all that fighting, I got to sing "Keep it Gay" on the big stage. It was everything.

CYNTHIA ERIVO

Actor, Singer-Songwriter

Born 1987 in London, UK

I guess the first time I remember sticking up for myself was at the end of my time at drama school. Knowing innately that I had been underserved, I walked to the artistic director's office and asked what their plan was for me during my time there. I told him of my experience and made it clear that it was not right. I got an apology that day, but really speaking my piece changed the way I saw myself.

JENNIFER VALKANA

Personal Assistant

Born 1987 in Santa Monica, CA

I will never forget the moment I knew I had to stand up and fight for myself. I also know I couldn't have done it without my mom's example. As an only child to a single mom who immigrated from Mexico and worked over thirty-five years cleaning and taking care of people's homes, I got a front-row seat to her ups and downs. I remember listening to my mom and my uncle talk about their workdays. As I grew older, I began to understand more and more about what they were talking about and unfortunately how people they worked for didn't always treat them with the respect and dignity they deserved. As I got older, I would ask my mom why people would treat other people that way. She would explain it the best she knew how and would always reassure me everything was going to be okay and not to worry because she would take care of it. She never broke that promise.

I think back to a day when I was in the sixth grade and one of my classmates looked at me and said, "You and your mom should go back to where you came from." Those words hurt then and still hurt today. What I didn't expect is how I reacted—the next thing I knew, he was on the ground, completely shocked. I had pushed him. Looking back, I know it wasn't my finest moment. Since then, I have learned that type of reaction isn't going to solve anything. It's not how my mom raised me.

My moment came the second week of December 2018. I was working for someone who wasn't properly compensating me for my time and work, but was expecting me to give 110 percent, which I did. At times, he would disregard my well-being as long as it served him or his business. It wasn't always like this, but it happened one too many times and was becoming a problem. For example, when I

was getting yelled at by a drunk business partner, his first question to me was, "What did you say to make him so mad?" Not, "Are you okay?" It broke my spirit. I was his right-hand person, but I was being treated as if I should feel lucky to have this job. I knew I had earned my job and my title by putting in the work. My mom witnessed my pain and frustration over the years, and it broke her heart, but she knew I was the only one who could stand up for myself. I decided to set up a call with him in regard to my check. He avoided answering the question. I knew then, no matter how painful the rest of conversation was going to be, I was done. I set aside how I felt at that moment, I remained professional, and I gracefully resigned from that job. I am blessed to say I never looked back.

FORTUNE FEIMSTER

Comedian and Writer

Born 1980 in Belmont, NC

I was twenty-three years old and I had just moved to Los Angeles. After using most of my money to drive cross-country from North Carolina, I had $25 left to my name and I had already maxed out my $250 credit card. A friend was nice enough to let me sleep on her couch until I figured something out.

I was so scared to be in this huge city where I barely knew anyone and I thought I had made a terrible mistake. I wanted so badly to throw in the towel and move back home, but something in my gut told me I had to stick it out. But just because your gut tells you something doesn't mean everything else falls into place.

It was one rejection after another and this went on for a while. Just trying to make new friends in Los Angeles seemed almost impossible. One day I called my mom crying, telling her I was sad, lonely, and broke. She said I could come home and sit around feeling sorry for myself or I could figure out a way to make it work; that if I came home now, I would regret giving up on my dreams for the rest of my life. It lit a fire in me. That's when I knew if I was going to try and make something of myself, I would have to be the one to make it happen. No one was going to hand me anything.

From that day forward, I worked harder than I ever had in my life. Comedy was no longer a job, it was my life's passion. I spent every moment trying to make myself a better performer so that the day an opportunity came, I would be ready. I also started making friends and soon LA started to feel like home. The biggest difference was that I was finally creating a life for myself; I was no longer waiting around

for life to happen to me. I fought for myself, for my career, for my friends, for my happiness, and even though it wasn't always easy, it was so worth it. Seventeen years later, Los Angeles is still very much home, I'm a working actor and comedian, my life has peace and balance, I'm surrounded by amazing friends, and I am beyond grateful.

SOLEDAD O'BRIEN

Broadcast Journalist, Executive Producer, and Author

Born 1966 in Saint James, NY

It was during the *Black in America* documentary for CNN. It sucked. I wanted changes. Everyone said I was difficult. My best friend said, "At the end of the day, it's your face. If it sucks, you made it suck. If it's great, people will think you made it great. Do what you need to do."

Our IT guy, Kelvin, is Black, and I had him screen everything with me and give me his feedback. Armed with Kelvin's and my notes, I rewrote the entire show with the president of the news division! No exaggeration. It got rave reviews. I got famous. Everyone hated me. I sort of didn't care. So many people's self-worth is bound up in making sure you know you're beneath their thumb. "Do what you need to do."

AMANDA FREITAG

Chef, Television Personality, Author, and Advocate

Born 1972 in Cedar Grove, NJ

What was my moment? This is a LOADED question for a chef (who happens to be female) coming up in the restaurant industry in the '90s! There have been many moments throughout my career and, surprisingly, I still fight for myself each day.

I learned early on in culinary school that I was going to have to work harder to prove myself. One of my instructors asked me, "Why are you here, why don't you just go to secretarial school?" I was the only woman in that class and the only one asked that question. It was clear I would face some challenges. I persevered, and it paid off.

Decades later into my career, in 2008, I was tapped by Jimmy Bradley to take over the Harrison, to breathe new life into the restaurant he owned. The beloved restaurant in the Tribeca neighborhood of New York City had become quite stale and not as lively as it had been in its heyday. I was up for the challenge and honored to be asked. It was a bigger job than I imagined. I was promised that the current team was "excited to work with me." The entire kitchen staff were loyal soldiers to the previous chef and were just waiting to join him in his new project. Over the course of the crucial first six months of my tenure, I had to replace the key players of my staff due to noncompliance. The sous chef, pastry chef, lead line cook were all gone, and I had to play all the roles myself. I put my own team in place and the magic happened.

I got to reap the rewards of my relentless work by receiving a two-star review from Frank Bruni at the *New York Times*. It may not mean as much now, but then it was the most important accolade for a chef in New York. I was proud.

In 2010, I moved on from the Harrison. I loved that restaurant, the team and family that made the show happen every night.

Then Jimmy Bradley spoke with the *New York Times* and crowned himself the chef upon my departure and told the newspaper, "She did great work. She's a good girl and she should be on to whatever her heart desires."

He called me a "good girl" as if I were a dog who'd just learned a new trick. I poured my heart, soul, and talent into that project, only to be deemed "a good girl." In 2010 we still didn't talk about how demeaning that was for a restaurant owner to speak that way about his successful executive chef. Oh, how different that would be today.

But the silver lining in that moment was that I knew I was ready to fight for myself and never let anyone disrespect or underestimate me again.

SOPHIA BANKS

Film Director and Photographer

Born 1978 in Stavanger, Norway

When I was young, I always knew I wanted to become a director. I enrolled in school and was immediately discouraged and told that I needed to enroll in the "female departments" due to my "inability to lift heavy equipment."

This was many years ago and in a time and place where women had even less of a voice in the film industry than we do today (we still have a way to go).

This brought me to the costume department, which led me into a wild and amazing career in first costume, then design and fashion, styling for incredible artists around the globe.

But after fifteen years, I looked back, and while I had accomplished so much, I wasn't fulfilled. And in speaking to a dear friend and female mentor of mine, it finally hit me that I was just scared. I was scared all of these years based on the opinion of someone else that wasn't my own opinion of myself.

That is when I decided I could have what I always wanted and saw a vision for my first short film and project with designer Christian Siriano, featuring beautiful women in couture gowns skateboarding down the moody streets of downtown LA. It was a representation to the world of my own personality and desire to succeed in

the predominantly male-driven film industry. After that, I went on to win awards and continued to expand my clientele, racking up work with amazing companies and individuals such as Pepsi, BMW, Chobani, Target, Anine Bing, and many others.

Knowing what I know now, I wish I would have made that decision earlier and will never question my own ability ever again.

CAROL BURNETT

Actress, Comedienne, Singer, and Writer

Born 1933 in San Antonio, TX

In 1962, my dream was to be in musical comedies on Broadway as the next Ethel Merman.

Also, in 1962, I was a regular performer on *The Garry Moore Variety Show*, but I really never dreamed television was going to be my "thing," even though I found myself falling in love more and more with the small screen. Garry's show allowed me to be different characters every week as opposed to doing one role over and over again in the theater. We mounted a musical comedy revue every week in front of a live studio audience, just like in summer stock.

However, I still saw myself as someday concentrating on Broadway.

In 1962, after I had been on Garry's show for a few seasons, CBS offered me a ten-year deal, from 1962 to 1972, which would pay me a decent amount to do a one-hour TV special each year, as well as two guest appearances on any of their regular series. However, If I wanted to do an hour-long comedy variety show of my own during the first five years of the contract, *they would guarantee me thirty one-hour shows!* In other words, it would be my option. CBS would have to say yes whether they wanted to or not! It was a pay-or-play deal because they would have to pay me for thirty shows, even if they didn't put them on the air. "Just push the button!" was the phrase the CBS executives used. This was an unheard-of deal, but it didn't interest me. I had no plans to host a TV show of my own. I was going to focus my energy on Broadway.

By 1966, I had married Joe Hamilton, who had produced Garry's show, and we had a daughter, Carrie, and another baby on the way. My Broadway career had not panned out and I was definitely *not* in demand. We had moved to California, where

we had scraped up enough money to put a down payment on a home. We were sitting on packing boxes and realized we had to do something to earn some money. It was the week between Christmas and New Year's: 1967 was right around the corner and our five-year deadline was about to bite the dust.

We picked up the phone and called CBS in New York.

Mike Dann, one of the top executives, took my call and seemed happy to hear from me. He asked about our holidays, and I said they were great but that I was calling to "push the button" on the thirty one-hour shows that they'd promised me in my contract five years ago. Mike honestly didn't remember any of this. I reminded him in great detail. He said he'd get back to me. I'm sure that several lawyers were called away from their holiday parties that night to go over the contract.

Mike called the next day and said he could see why I called, but he didn't think a comedy-variety hour was the best thing for me because "comedy-variety shows *are a man's game.* They're traditionally hosted by men: Gleason, Caesar, Benny, Berle, and now Dean. Dinah Shore's show was mostly music."

I countered with, "But comedy-variety is what I do best! It's what I learned doing Garry's show—-comedy sketches. I want a rep company like Garry's show and *Caesar's Hour.* Guest stars! Music! Dancers!" Mike didn't want to give in: "Honey, we've got a great half-hour sitcom that's right up your alley. It's called *Here's Agnes!* It's a slam-dunk!"

"*Here's Agnes?* No thanks. . . ." I pushed the button.

A man's game? I don't think so. . . .

REBA McENTIRE

Singer, Actress, and Entrepreneur

Born 1965 in McAlester, OK

The moment in my life when I realized I was ready to fight for myself might've happened at an earlier time but the one that stands out the most happened in the middle '80s.

I was working on an album with my producer, Harold Shedd.

Harold is a wonderful producer who has worked with many great artists, but I wasn't happy with the songs or the production that Harold was presenting to me.

Jimmy Bowen was the head of MCA Records at the time. Jimmy is known for producing many acts—George Strait, Dean Martin, and Frank Sinatra, to name a few.

So not being happy with the progress of my album, I went to Jimmy Bowen and expressed my concern. I told him I wanted to do "my kind of country." Country songs with a steel guitar and a fiddle as the production, not an orchestra.

Well, he looked at me and said, "Well, woman, go find your own songs."

I said, "How do I do that?"

He said, "I'm gonna send Don Lanier"—who we called Dirt, that was his nickname, honestly—"to go out with you and find the songs that you like."

So we did. Dirt and I hit every publishing company we could find and listened to tons of songs. We had a blast!!!

That's when we found "Whoever's in New England," which became a single and the title of my first gold album.

I give God all the credit for giving me the instinct and the wherewithal to go fight for my album. He always sends me in the right direction.

All I have to do is be still and listen.

It's a great feeling to know God is always on my side.

RENÉE FLEMING

Operatic Soprano and Advocate

Born 1959 in Indiana, PA

It is difficult, maybe impossible, to pin down one single moment when I realized I had to fight for myself; because I have, in some ways, been doing that my entire career.

Maybe that struggle is rooted in the special nature of singing. The voice is probably humankind's oldest form of artistic expression. Neanderthals had the same vocal apparatus we do. And singing is the most personal kind of music-making, because the instrument lives inside us. The sound is unique to each individual; like snowflakes, no two are exactly alike.

So finding your voice, and what makes it special, is a process that begins the very first time you utter a sound. For me, as for many singers, this has involved literally thousands of hours in a practice room, discovering and building my instrument. Of course, I needed great teachers, and I benefited from the guidance of artists who came before me. One of my favorite traditions of classical singing is the way knowledge of best practices and techniques is handed down from generation to generation, now over three centuries.

But as an American in a predominantly European tradition of classical singing, I was consistently offered a narrow, prescribed road map for my career. From the outside, my path might look like a rewarding string of successful engagements, but the truth is more complex. Standing up for myself has been a constant, indispensable factor in almost anything I have achieved. Managers, agents, directors, and coaches each had plenty of advice—always built on their own experience and well-meant—about not only what music I should sing, but also when and how I should sing it. Somehow, I was fortunate to find strength to trust my inner voice

and intuition. One indelible lesson came when the great Leontyne Price told me to tune out all the noise and "listen to this," indicating her throat, and meaning the voice itself, as the most elemental teacher of all.

At first, the challenge was to stick with the roles and repertoire that were right for me. Only we can know what's comfortable and joyful to perform, because we are all so different. The secondary battle was about following my musical passions across boundaries, to explore genres that others told me were inappropriate or off-limits. Again, I somehow found the fortitude to perform and record the jazz, popular songs, and musical theater that my wide-ranging taste encompasses and that are part of my cultural identity as an American.

As a result, I now consistently encourage young artists to explore the entire treasure trove of music on offer, and to create a body of work as individual as each of us is. This may seem contrary to our academic system of preparing performers, but there is a way to learn the craft and techniques from our teachers while discovering and dreaming about who we will become.

LIZ LAMBERT

Hotelier

Born 1963 in Odessa, TX

I would like to say that the moment was in second grade, when I punched a blond-haired boy in the face and gave him a bloody nose, out behind our west Texas classroom during play period. But that wasn't as much a decision to fight for myself as it was a natural response to an invitation to throw a punch ("Go ahead, hit me," he said). With three brothers and the confidence wrought by love and privilege, my self-assurance was hardwired by that point. If I wasn't born in a power pose, I had mastered the stance by seven.

So it wasn't on the playground but decades later, on a bigger stage, when my partners and I sold control of our hospitality company to a more established brand. My team and I had spent years building the company, with sweat and tears and joy and heart. We were far from perfect, but we had nurtured something very special over the years: a hotel company that brought kinship and meaning to many who worked with us and stayed with us. By intention or by accident, people found themselves in our lobbies, our courtyards, our rooms, our bars. Love was begun and ended and begun again, children conceived, victories celebrated, and sorrows drowned. We came of age together. We made mistakes, and we grew, and we had wild fun. We had built that "self-maintaining fire which is the quality without a name," that architect Christopher Alexander has described.

We sold a majority stake in the company, looking for a more high-profile platform, financial stability, and extended support for my team and our vision. But eventually, personal bonds and words of honor lost out to hard-hitting business, and to a whole new set of values other than the ones to which we were accustomed. We

would be forced to shift our focus from nurturing and growing something special to focusing only on rapid growth.

When I fully understood the impact that all of this would have on our company, I began to fight: I fought to save the brand we had created, for my family, for our team, for all of us. And I fought with myself about how I had opened the gates, how I could have ever been so trusting. I fought to understand the odd elusiveness of gendered power that I thought I had escaped. I fought to forgive myself.

I was eventually fired for fighting. It was devastating to walk away from the places we had created, and away from the people I loved so deeply. It's hard to find meaning these days in places and in people, and harder still to relinquish a place and people that are infused with it. Though, as time went on, I realized something: I had been fighting for myself, and for us, all along. I had been fighting a world that is short on joy and beauty with all my heart, and with a team of enormous hearts by my side. We had been fighting to create, even for small moments, something bigger and deeper than the usual way of doing business, fighting to make something more than a commodity to serve the maximization of profit—and that is a fight no one will ever be able to take away from us.

And so I carry on fighting.

JUDY SEALE

President and CEO of Judy Seale International, Inc., and Founder of Stars for Stripes, Inc.

Born 1952 in Clanton, AL

The journey my life has taken me on was never somewhere I imagined myself being. Some of the defining moments were brought about by experiences that I found devastating at the time. For many years, I was a partner in a music industry management company. We had a very diverse roster of entertainers and I loved working with every one of them. I worked nights and weekends and holidays not because it was required, but because I loved what I was doing. One of the female entertainers on our roster became increasingly difficult to please, to the point that spending the necessary time with her was extremely depressing. Eventually, because of her abuse, I was forced to resign my position and made the frightening choice to start my own company.

For more than a decade, I had been working with foreign promoters to bring country music artists to their events, many times helping them establish the first country music festival in their country. I've been blessed to introduce country music to Japan, Hong Kong, Brazil, Thailand, and so many other places around the world. In total, throughout the years I have worked to bring entertainment to and visited approximately seventy-nine countries around the world. For many years I also donated my time with the USO to solicit entertainers to perform for the men and women deployed overseas. My very first tour was to Iceland for Christmas in 1991. It was life-changing in so many ways, and to this day, I stay in touch with the pilot who flew us from Nashville to Iceland in a P-3 submarine surveillance plane. I continued donating my time to the USO and several other organizations so that I could support the military throughout the years. In 2003, I was with the first group of entertainers allowed to entertain the armed forces in Iraq. After our arrival in

Kuwait, there was an unfortunate altercation with one of the coordinators when he refused to allow the entertainer I was accompanying to participate with the group going into Iraq. Again, a moment in time that forever changed my life. I fought and won, and we were allowed to go into Baghdad. Upon my return to the US, I started my own nonprofit organization dedicated to providing quality entertainment to the men and women deployed overseas. To date, I have personally escorted more than 150 tours with thirty-nine of those going into Iraq and fifteen into Afghanistan—all during the most dangerous time of the conflict.

I learned that my commercial business fills my pocketbook, but my tours for the military fill my heart. Every military tour had a special moment that forever lives in the memory of those of us participating. I will forever be grateful to the numerous entertainers willing to donate their time and follow me around the world to personally thank our armed forces. I would never have dreamed that this little country girl growing up in Alabama would ever lead the incredible life I lead. But I definitely never chose this path. Circumstances forced me find a way to survive, and I learned to fight for myself. I thank God every day for challenging me and guiding me to become the person I am today.

TINA TCHEN

Lawyer and Former CEO of Time's Up

Born 1956 in Columbus, OH

It was sometime in my late twenties during my first year working at a large, national law firm, which had just recently opened a Chicago office.

Although the number of Asian Americans in the legal field has quadrupled in recent years, back in the 1980s, being an Asian American woman in law—and specifically doing litigation—was unheard of.

A lawsuit filed in Chicago threatened a major deal that my firm was working on in our New York home office. The judge in Chicago scheduled an emergency hearing and we needed a litigator to run to court and argue the case. Because our Chicago office was new, there were only three litigators working there at the time, and I was the only one in the office that day. So even though I was only two years out of law school, I got tapped to go.

I remember going to court and feeling the adrenaline and anxiety rushing through my veins. I shook off the nerves, fixed my blazer, put my lipstick inside my portfolio, and gathered my legal notes before entering the courtroom. This was a big case, with lots of different parties, so when I walked through the courtroom doors, I saw ten lawyers standing before the bench, each of whom was at least fifteen years older and a white man. I was the only woman, the only person of color, and definitely the only person whose law school diploma was still in one of my moving boxes. I stood quietly in front of the judge, lined up with all of those men, as the lawyers began to argue.

I won't get technical, but basically, I got an idea about an important legal principle, which no one had yet raised. If I was right, the principle would put an end to this whole case challenging our deal. But I stayed silent, thinking, *What if*

I'm wrong? I must be wrong, since no one else has raised it. So instead of interjecting my argument, I whispered to the lawyer next to me, "Hey, they can have money damages, right?"

Next thing I know, he took my argument and shouted, "What about money damages?!" I just stood there blankly for a few moments in astonishment. The judge agreed with him immediately, putting an end to the case.

He stole my idea and was praised as a hero for that argument. I never made that mistake again.

That was the moment I realized that I had to trust my gut and fight for myself.

I used to think that this experience was unique to me. But sadly, when you're the only woman, person of color, or LGBTQ+ person, or the only worker with a disability in the room, experiencing a crisis of confidence—or "imposter syndrome"—is all too common.

And it can happen at any point in our lives. When I headed the White House Council on Women and Girls, I remember seeing senior aides experiencing imposter syndrome.

Now, almost thirty-five years later, whenever I hear about big and small crises of confidence from other women—and especially younger women and girls—I tell them: "Don't let others steal your voice."

Instead, do what I wish I had done: shake off those feelings, validate yourself, and be confident that you've got what it takes to succeed. If you're in that room, trust that you've earned your right to be there.

STEPHANIE HOPSON

Music Business Executive and Open Water Swimmer

Born 1976 in Minneapolis, MN

By the time I was a teenager, I knew I wanted to work in the music industry. I'd spend hours in my bedroom listening to music on a boom box. I recall my dad, a music lover himself, saying to me, "Turn that off—you'll never grow up to make a living from that." I don't think he was trying to crush my dreams, but rather giving his only daughter some advice about how the real world works. My dad grew up in a poor west Texas town during the Great Depression. Before I was born, he'd done a long stint in prison for robbing a bank and had hard-earned insight into how life can deliver someone a hefty dose of disappointment.

It would later be my dad who took me to my first recording studio. Not long after that visit—and right before my fifteenth birthday—my redemption-finding, Waylon Jennings–loving, crazy-about-his-little-girl father passed away, leaving me with a hole in my heart the size of . . . well, Texas.

My mom was a strong, educated woman with a long career as a public-school teacher in Minneapolis. Despite the loss we'd suffered and her suddenly being a single mother, she continued to teach me to dream big; always making me believe I could do anything. With that wind in my sails, I'd go on to graduate from Pepperdine University, majoring in public relations and minoring in religion. Both areas of study have proven considerably important in my life.

And, just as I'd always hoped I would, I found my place in music. For nearly twenty-five years, I've enjoyed working with artists to bring their work into the world.

Many years ago, I was interviewed by a student for her college paper on women in the music industry.

"Have you ever felt you've been treated differently because you're a woman?" she asked.

I replied, "No, I don't think I have. If you work hard and do your best you can achieve anything regardless if you are a man or a woman. I've never been treated unfairly or haven't had an opportunity because of my gender." I knew that wasn't the response she thought she'd receive.

A determined optimist, I wanted what I had said to be true. I've thought of that moment a lot—especially when I swim.

I'd made a quiet decision, after not swimming seriously for two decades, to swim the English Channel—twenty-one miles from England to France, no small feat for anyone, not to mention a woman who'd heard clearly that a body like hers isn't the body of an athlete. I am five feet nine inches tall and at the beginning of my two-and-a-half-year training period weighed about 260 pounds. I would come to learn that the body I spent years apologizing for was perfect for long swims in cold water.

My English Channel swim began on August 9, 2016. With a hired escort boat, a boat pilot, and four of my best friends, I began my swim.

Eleven hours into the swim, the propeller of the boat got tangled in the lines of a lobster pot in the middle of the Channel. The confusion and chaos that ensued were compounded by the dark of night and the powerful water that separated me farther away from the suddenly still boat—now a faint light in the distance.

I swam for my life back to that boat. A few days later, I jumped in again. A solo swim is anything but solo, and even though I was the only one in the water, I wasn't alone. Love got me to France. I walked up onto the shore after swimming twenty-four hours and thirty-one minutes. More people have summited Mt. Everest than have swum the English Channel.

Once I was home, a male colleague made an offhand comment to me, one I'm sure he found encouraging: that my swim would change the way people see me at work and have a positive effect on my career. Later, a friend said, "You mean to tell

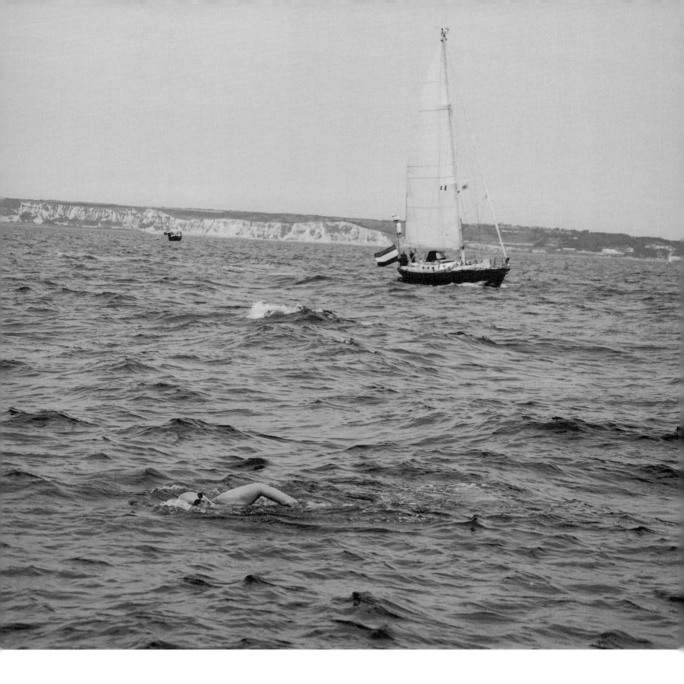

me a woman has to swim to France in order to lead a meeting at work?" It was in that moment that something clicked.

As women, we're expected to have matching if not greater accomplishments than our male counterparts in order for our voices to matter the way theirs do. The

problem begins early when we aren't given the same access to opportunities that they're given. This dynamic perpetuates the inequity. And often, when we're the only female voice in the room, we're made to feel lucky we were even allowed in there in the first place. At every turn, we are asked to be the best, only to fall short in terms of being acknowledged. I often wonder how many women—after years of feeling unheard—stop talking.

I don't just want a seat at the table, I want the table.

It's taken me many nautical miles to begin to understand why I would answer the question the way I did. "Have you ever felt you've been treated differently because you're a woman?" Yes—and now I have the courage to say it.

ALI STROKER

Actor and Singer

Born 1987 in Ridgewood, NJ

My moment began on June 9, 2019. I was nominated for a Tony Award and was asked to sing "Can't Say No" at the awards. It was the most nervous I'd ever felt in my life. It was double nerves. The day was filled with rehearsals and a matinee of *Oklahoma* and red-carpet photos and interviews and multiple costume changes. I met lots of new people and was comforted by having my partner, David, by my side through most of the day.

Then came the moment to roll out onstage to start "Can't Say No." I got center stage and a note played in my in-ear monitor and it was time to begin. I looked out at Radio City Music Hall and saw thousands of people with their eyes on me. I knew millions of people were watching on TV and it was my moment. I took a huge breath and began. And in that moment I had arrived. At my dream. At the place where so many people thought I wouldn't be able to get. The whole world stopped and it was just me. And I felt peace.

Fifteen minutes later I won the Tony Award for best supporting actress in a musical. When I made my speech, I dedicated the award to all the kids watching who had a disability or a limitation. It was no longer my moment, it was our moment. The disabled community had arrived in a place they had never been. I thought about seven-year-old Ali, who never saw anyone like her, in the theater community. Winning was icing on the cake.

My purpose and focus are about not just my own dreams but the dreams and future of my community. I move forward now knowing I am representing the disabled community in every moment of my career. I feel so grateful for this life I have been given.

JEAN BRADEN

Nurse Practitioner

Born 1958 in Glasgow, MT

Boy, oh boy. I don't think I ever really knew my strength until I was left dangling from a cliff in 2007 when my husband died very unexpectedly. He was fifty-one. I was forty-eight.

Morris was the kind of guy who took care of everything and I felt adored and sort of oblivious to the ways of the world. I always worked hard, but never had to seriously pay attention to advocating for myself.

I worked for an organization that I truly believed in and I had rationalized that my low pay was okay because I was devoted to the mission of helping women being able to "contracept"—regardless of their ability to pay.

Suddenly, though, when my husband—a physically fit and otherwise healthy guy—died of a cardiac event, I was without his income; facing college tuitions for our two daughters, Hannah and Megan; and thrust into running Morris's company, which I knew nothing about. I was completely unprepared.

I was scared out of my mind, grieving the loss of my best friend and truly getting emotionally annihilated as I watched the grief in my girls at the loss of their dad. The whole thing was a baptism by fire. At the end of six months culminating with the sale of his business, if you had thrown me to a pack of wolves, I would have felt like I could have taken them all on and come out scratch-free.

I had people trying to take advantage of me from all fronts and really did not know whom I could trust. It was truly survival of the fittest and I discovered that it was me I could trust and a small group of my women friends who will forever be "my people."

Before that moment, I had always believed women would save the world but

now I know just how much the gut instincts of most women are so right on, and when faced with hard choices we go out of our comfort zone to lend a hand and speak the truth.

I left Planned Parenthood because my boss decided not to honor my request for an honest wage. It was the first time I'd ever asked for what I deserved and it was so hard.

I have since asked for what I deserve, backed up my request with hard data, and have never been denied. I'm not greedy, but I know my worth.

I have passed this strength and self-confidence on to my girls. Megan is so good at negotiating that it floors me and leaves me laughing my head off! I once had a car dealer call me back to his office to try to get me to "talk some sense" into my daughter. Megan was twenty-one years old and negotiating to buy her first car on her own.

I told him that she'd done her homework, she knew her offer was a fair deal, she wanted the car, but she was never going to give him one cent more than her offer.

"I would, but she won't!" I told him as I stood up to leave his office. "And don't let her beautiful, sweet demeanor fool you. She will leave this place smiling one way or the other, with or without a new car," I assured him.

He sold her the car.

JILL FRITZO

Founder of Jill Fritzo PR

Born 1970 in Easton, PA

My mother was from Denmark. She was a strong "Viking" and taught me strength. My father was Italian, a business owner, and I'm sure I got some strength and guts from him, too. I had two older brothers who also paved the strength road for me.

My father died when I was nine. Mom became a single parent, went to work, cared for me. She was my strength and support along with my brothers, who by that time were out living on their own.

I always wanted to be in the entertainment industry. I worked hard, went to college, moved to New York City, and got a job. My first job out of college became the place I worked, for twenty-four years. I learned, I grew, I loved my job.

But 2001 was a tough year. My oldest brother passed away, I lost a client in a plane crash, and I was in NYC on 9/11. Work was my world that kept me going. Taking care of others. Now I had to be strong for Mom, who'd lost her son. Mom also had some heart troubles through those years, so I spent a good amount of time taking care of her and not minding it one bit. As long as she was okay. In 2010, Mom was diagnosed with lung cancer. I became her caregiver for the next five months. I kept my job going, often looking to work as my escape. Mom passed in 2011, and now it was just my brother and me. I was always worried about him and how he was handling the family losses. It was my mission to make sure he was okay as much as he thought it was his mission to make sure I was okay. He had some health issues that put him in and out of the hospital in 2012 and 2013. I stayed with him and took care of him the best I could while holding down my job. In 2015, he was diagnosed with lung cancer and passed the same year. I had been working from the hospital and from home with my brother.

So, there I was. Alone. My family had passed. This was my moment.

I got this, I would tell myself. *I am going to be okay. I am going to enjoy every day, the best I can.*

So many times I had thought about opening my own company. My brother and I discussed it. He pushed me. I had some great friends who pushed me. But I was terrified. No way would I be able to do it.

My job was all-consuming. I loved it, I thrived off of it, I drew strength from it. My escape. After my brother passed around Christmas, I made up my mind. I was going to do it. I was going to leave the place I'd worked for twenty-four years and do it on my own. It was a new year, 2016. I knew leaving wasn't going to be easy. But I had to do it. I had to do what was right for me and my life. This was about what was going to *make me* happy. I was fighting for me. Although it was a bit of a struggle, I did it. I opened Jill Fritzo Public Relations in 2016. My family always championed everything I did. I had a great support system growing up. I know they were with me every step of the way, even though they were no longer physically here. I know they are proud. It's almost five years now with JFPR. I have employees and a bicoastal presence. Still building, still growing, still learning.

Interestingly, once I found my moment, my moment never passed. Thankfully, it became my reality.

MAGGIE SMITH

Poet, Writer, and Editor

Born 1977 in Columbus, OH

When I was thirty-four, I quit my job as an editor. I didn't know if I could hack it as a freelancer, but I wanted a different life for myself. I was finally ready to try.

For seven years, I'd been working full-time in educational publishing, a regular nine-to-five gig. I'd published one book of poems, *Lamp of the Body,* and was plugging away at a second. My writing time was compressed: I wrote on my lunch hour and in the evenings after my toddler was asleep. My parenting time was compressed, too: I was with her in the evenings and first thing in the morning, in that mad rush as I was getting ready for work and taking her to day care.

The freelancers working for the company were doing what I was doing, creating print and digital materials for elementary reading and language arts programs: teacher editions, student workbooks, transparencies, flip charts, assessments. But they were doing it from home.

Watching from my cubicle as they walked in and out of the building, I'd think, *When they meet a deadline, they can stop for the day. They can work on a project of their own. They can take their kids to the zoo.* When I finished my own tasks, I couldn't just clock out. My reward for being efficient was more work—often the tasks of coworkers—to keep me busy until it was time for me to leave.

One fall I received thrilling news: I'd been awarded a Creative Writing Fellowship from the National Endowment for the Arts. The federal government had invested in me as a poet, and I wanted to honor that. I wanted to invest in myself, too.

I wanted to attend a writing residency—to immerse myself in a project for a couple of weeks—but it was not possible with the amount of vacation time I had accrued. I asked my boss if I could transition to freelancing for the company.

The answer was no.

I had a difficult decision to make. I weighed the risk against the potential rewards, and I decided to take a leap. I decided to fight for myself. I quit.

I knew I would not be freelancing for the company I was leaving, but I could find other clients—and I did. The NEA grant in the bank was my safety net. If my work dried up, I could pay bills with that money until I figured out a plan B. Over the next several years, I spent the grant on writing-related expenses—manuscript submission fees, conference registrations, travel for readings—but I didn't need a plan B. I'm still self-employed.

Soon after leaving my job, I attended my first residency at the Virginia Center for the Creative Arts, where I completed my second book, *The Well Speaks of Its Own Poison,* and began work on the poems that would become my third book, *Good Bones.* That experience was transformative for me. I was there, immersed, dedicated. I was *really doing it.* At VCCA I met writers, composers, and visual artists from all over the country who were really doing it, too.

I befriended Kathy, a paper artist from Baltimore, and I was inspired to write the hawk-and-girl poems in *Good Bones* after seeing her intricate work. I met Dennis, a composer living in New York City, and we've since collaborated on not one but two pieces pairing my words with his music. To this day, I'm grateful for the sense of community I had with other artists—Kathy, Dennis, Marie, Sally, Dan, Olive, Jim, Peggy, and Walter, among others; the cross-pollination that happened during the residency; and the creative momentum that carried me long after I left.

When I returned from my time in Virginia, I changed my daughter's day care schedule from full-time to part-time. On the days she was there, I worked—hard, but efficiently. Usually I reserved mornings for my own writing, then spent afternoons on client work. On the days my daughter was home, we played, baked, went to the library for story time, visited the conservatory or the zoo—and then I'd work again, or write, after she went to bed. Those were long days and late nights, and, yes, it was all worth it.

There have been many moments in my life when I've had to fight for myself. Sometimes I've been able to quietly claim—or reclaim—my space. Other times I've had to throw a proverbial elbow. What I know: If I hadn't taken the risk and left my salaried position, my life would be much smaller today. I was told *no*. I said *yes* to myself.

ROSIE O'DONNELL

Comedian, Actress, Talk Show Host, Author, Producer, Activist, and Philanthropist
Born 1962 in Commack, NY

it was a cold day in april 1973
a month after my mother died
the five of us were watching tv in the playroom
timmy—the baby of the family—was not feeling well

he jumped off the brown plaid couch
and tore toward the bathroom
before the entrance—6 feet from the bowl—
he stopped and threw up

shocked at the mess in front of him
blocking his way
he froze in his feety pajamas
as another round was churning

i ran toward him—
grabbed his tiny body
and walked through his puke to the target—
the toilet

he retched a few more times—
as i held his forehead—wiped his baby mouth
he looked up at me and quietly said
"you have to be the mommy now"

that moment i felt everything shift inside me
i left my childhood behind—
to take my place in the world of adults
where eleven-year-olds don't belong

i placed armor
around my heart and soul
determined to get us all through
our motherless existence

we were one—the five of us
like fingers of a hand
stronger together
we moved as a group

fighting the battles of childhood
physical and emotional
i learned to stand up for myself
while standing up for them

SUCH

Singer-Songwriter and Actress

Born 1985 in Boston, MA

They say the role you play in your family, unless you're intentional about changing it, is the role you'll play in life. I spent all of my childhood and my adulthood up until I was twenty-five being a people-pleaser, with this overwhelming need to be liked by all I came in contact with. Maybe it's because I was the youngest of three sisters and anointed myself the keeper of the peace (according to my parents my sisters fought incessantly until I was born), the person bringing joy to everyone. Even when their happiness was detrimental to my own. I would take it all in silence. Being the youngest I was in a position where everyone felt like they could tell me what to do and how to do it because they were more experienced and in my culture kids questioning adults was a no-no. I never wanted to rock the boat, I just wanted to make sure everyone was content. Part of that was this role I was born into, the other part was nature—my personality perhaps. No one encouraged me to advocate for myself so while I was a bossy little girl, I didn't have a voice. Didn't know my voice mattered.

The moment I realized that it was time for me to fight for myself was when I pushed my son out of my womb. It may have had to do with the fact that labor and delivery were the closest I'd ever been to death (not out of a difficult birth but because at any moment during labor if one thing were to go wrong it could be life-or-death), or the acknowledgment that I had grown a whole human being—with thoughts,

223

feelings, dreams, a beating heart—and aided his entrance into the world. When I heard his cry and subsequently gazed into his eyes for the first time, I felt something unleash inside of me—like a champagne bottle being uncorked. A loud pop in my soul and a deep realization and confirmation that I was a badass.

I started to fall in love with myself. I'd been afraid that I would lose myself in the role of becoming a mother, but that's actually when I found out exactly who I was. That's when I started to fight to be my truest self, decided not to shy away from confrontation, and became comfortable with not being liked by everyone. I knew that I wanted to be an example of freedom for my son. No matter how hard things get, I can always look back to that moment, the uncorking of my soul, and pull from that strength and knowledge that I am an incredibly beautiful, resilient, soft, raw, funny, assertive, patient, caring, loving person, and strong Black woman. And she is absolutely worth fighting for.

FELISA IHLY

Attorney and Pro Bono Specialist

Born 1951 in Los Angeles, CA

The moment I learned to stand up for myself as a woman was also the moment I learned to stand up for myself as a mother.

As a working mom in conservative Orange County, California, I did the infamous juggling act, balancing a legal career with raising two sons. When our youngest came out as gay, I tried to be as supportive as I could be, but I was completely ignorant of gender expression. It was 1996, and hardly anyone knew what "transgender" meant at that time, certainly not me or my child.

When Shakina began wearing makeup to school, painting her nails, and dressing in what I assumed to be drag, I was completely clueless as to how to handle it. I wondered if this was how gay teens acted out. Was it something she would grow out of? Was it a sign of something more serious from a mental health perspective? As we both struggled to understand what was happening, she began to have problems at school. She was frequently harassed and bullied, and in response became an activist, leading marches for gay rights, founding a gay–straight alliance, passing out rainbow wristbands, and challenging faculty and administration who wanted nothing more than to keep her "in the closet"—and away from campus.

I didn't fully understand what was going on with my daughter, but my maternal instincts kicked in hard and fast. I was at the school multiple times per week and was met with obfuscation and excuses by teachers and administrators who refused to commit to protecting her. My foremost goal was to support and protect her, physically and emotionally, and then get her off to college where I knew she would be okay.

GAY: Brewer played key role in harassment bill

FROM 1

vene to stop any harassment. If he vetos it, Ihly and others will try again next year.

But that's the public process: the legislative steps ...urists can read about in tiny ...rochures handed out during ...urs of the state Capitol.

...hat can't be seen on any ...r is the influence that ...isa Ihly and her son Jared ...fack had on the Legislature this year.

...y's Mother's Day appeal ...ed many responses, but ...nost notable was an al-...unprecedented two-page, ...ritten response from ...blywoman Marilyn ..., R-Newport Beach.

...story of her and her ...of course very mov-...id Brewer, who had ...ly voted against a ...ill and this year ab-...om voting on the pro-...

"Of course it had an ...e."

...nfolded a piece of ...e stood on the As-...r. It was the word-...ed in the bill. And ...t this was the lan-...ost to the word — ...nded into the bill ...tely garnered ...o allow it to pass ...ouses.

...rewer helped ...She never vot-...d to the outside ...uninvolved. ...is how she'd

have to endure being torn apart by the very institutions to which they entrust the education of their children."

Ihly's son "came out" on his 15th birthday just before a big party she threw for him in the family home. Looking back, Jared is amazed at his mother's ardent letter writing in view of what happened just three years ago.

"I remember telling her, and she cried. At my party I came downstairs in drag and she screamed, 'Why do you want to be a girl?!'" said Jared, now 18 and a sophomore at the University of California, Santa Cruz. "It was very uncomfortable for her, but she accepted me."

Which is all Jared says he wanted from his school. In the end, mother and son both say, school administrators did not stop the bullying and death threats. Instead, they asked him to tone down his self-described "flamboyant" style.

He says school officials questioned his use of makeup, fingernail polish and the bright shirts he liked to wear. The principal at the time has since retired, but other Dana Hills and district officials familiar with Jared's senior year refused to comment.

"Students have protections under the law and we don't comment on students or former students," said Tony Monetti dist...

YGNACIO NANETTI/The Register
CRUSADER: Felisa Ihly says her son Jared, left, was taunted by classmates for being openly gay. A bill she championed could soon become law.

that went far beyond protecting students like Jared from harassment. As first introduced, the bill was 33 pages long, would have required 23 amendments to the state Education Code, and would have added four new sections as well, Brewer wrote to Ihly.

She said if the bill's lead author, Assemblywoman Sheila Kuehl, D-Santa Monica, really wanted to protect students she would have introduced a "clean bill" with straightforward language. Her concern — as Brewer expressed in interviews — was that the law would trigger a need for new textbooks and force private religious schools to betray their beliefs.

At the time, there was only one state in the country that had laws prohibiting discrimination and harassment in public schools based on sexual orientation or gender identity. There were efforts to pass such a bill in California, but they were met with little success. When I became aware of renewed efforts to pass a similar bill, I felt compelled to write to the bill's sponsor, tell our story, and offer to help.

On Mother's Day 1999, I wrote letters to all the mothers in the State Assembly, where the bill was pending. I told them of the trauma that our family had endured, and how a law such as the one they were considering would have helped us. I received several personal responses, in particular a two-page handwritten letter from one of the bill's most vocal opponents. In the letter she conveyed the type of language the bill should contain to stand a chance of passage. I passed this information along to the bill's sponsor.

Later that summer I got a phone call from a political reporter up in Sacramento. She told me that the language I forwarded eventually became an amended bill, and in addition, several of the legislators said they felt moved by my letters and changed course to support this new version! I listened to the reporter's explanation and I could barely breathe. To realize that our story had such an impact, not only as a legislative victory, but as something that could actually save the lives of LGBTQ children, was overwhelming. I thanked her, hung up the phone, and burst into tears.

The California Student Safety and Violence Prevention Act passed by one vote and was signed into law by the governor, adding actual or perceived sexual orientation and gender identity to California schools' existing nondiscrimination policy. It remains the law in the State of California today.

aretha marbley

Professor and Director of Community Counseling

Born in Pine Bluff, AR

June 11, 2020, the fifty-first anniversary of Mama's death, I sat at my desk, feeling helpless, looking up at the sky through my window, reflecting on my power while typing a case story of Black women who survived Covid-19 and the Spanish flu. I paused for a moment of silence for my Black female ancestors who survived both.

One of my earliest memories of feeling powerful happened when I was about five years old. One clear, bright sunny day, I stood out in the open field in the middle of our farm in a small town in the backwoods of southern Arkansas, looking up thoughtfully, squinting reflectively at the sky and having an in-depth conversation with the universe, perhaps myself, when I realized that I had descended from a long line of women. The verbal exchange went something like this: "If my mother had a mother and she had a mother, and she had a mother, and she had a mother, then who was the first mother?" I stood there for an eternity seeking answers to this intriguing puzzle. I could go backward in time, but I had no concept of going forward. It never crossed my mind that I might have daughters, granddaughters, and great-granddaughters. Strangely, I never shared my insight with another soul. Instead of asking Mama the names of her mother's maternal genealogy, I searched the sky and universe for those answers—for power.

I did not know that I would survive the Black and feminist movements of the 1960s and 1970s or the end of Jim Crow in the South. Neither did I know that I would survive homelessness, the loss of three mothers, father, sister, two brothers, three best friends, and other close relatives. Today, I wish that I had sought the names of those already lost, direct descendants of African slaves whose identity was snatched from Mother Africa's bosoms and their African mothers, and even

their African American slave mothers, much as they themselves were. But even the question was a gift.

So many years later, the Black women ancestors in the narrative who wiped away my tears gave me their collective power. I had begun on the anniversary of Mama's death; I finished on the 111th anniversary of her birth, Thursday, August 6, 2020. I wrote, "As they stood together at the intersection, hope battled through my grief and fear, wiped angrily at the tears in our eyes, silently knocking on our cynical hearts, and finishing my manuscript." My female ancestors helped me to realize my strength and to accept their power, the power of the universe, and the power of God. I will continue to use this power in my clinical work, activism, and writings to clean our unhealed wounds and lingering trauma from centuries of oppression.

In all this I have company: amidst the Covid-19 pandemic, there has been civil unrest for justice, the Black Lives Matter and #SayHerName movements, and Kamala Harris became the first woman US vice president of African and South Asian ancestry. Now, as then, I reach back to my ancestors. Looking up at the heavens, I feel elated, serene, and empowered! For me, this presidential inauguration was a defining moment, an opportunity to rejoice and ask questions, and to fight for myself and my female ancestors and my female descendants. I can now appreciate and accept that power and time are inversely proportional, as I rise up out of dark circumstances, pause for a moment of silence to honor my female ancestors, and thank them for sharing their power with me.

RIYA GOEL

Student, Author, and Activist

Born 2004 in West Orange, NJ

Fighting means a lot of things to a lot of people. Fighting for me meant fighting for justice, fighting to make the world more inclusive, and fighting inner demons to realize that I was enough no matter what I did.

My demons included insecurity, imposter syndrome, and a feeling that no matter what I did, it was never enough. These demons were the product of society, family, toxic friends, teachers, coaches, and most of all, expectations. To tackle these demons, I tried to fill my plate up with things to do, so that I would never have time to think about them, but I realized that I was dodging the problem instead of facing it. What really helped me face my demons was finding community. Being able to immerse myself in communities where I met people that cared about the same things that I did is when I felt understood, and could open up about what I had been experiencing.

It turns out that although I had all the ideas and potential in the world, I'd have to find the strength, resilience, and persistence within me to stay committed and passionate about my ideas, and also face any of the backlash that came with it. Backlash came in all shapes and sizes. It meant administrators that wouldn't meet with one of their students until about 50 follow-up emails, people who didn't take me seriously because of the way I talked, the color of my skin, or even having to hear from those closest to me about how none of my ideas would work.

I realized I was ready to fight when people would tell me the word *no*. Although the two letters have a lot of power, and end up stopping a lot of people, I always found a way to make the two letters into three; a *yes*. The several no's I received empowered me to do more, to follow up more, and fight for what I thought was

right. I think I received no's because of my lack of experience, people underestimating me and what I could do, or even people being intimidated by what I could do, and the insights that I could bring.

Intersectionality was another thing that empowered me to fight. I realized that my own perspective was just one way of looking at the world, and that others looked at the same set of issues I was working with through a different lens. I realized issues facing our world are more nuanced than we think, and that every view is important as it explores a different side of a particular issue.

I don't think I ever expected to become an advocate. The future is all about finding the things you care about, and making a way to make those passions work for you, but also embracing the unexpected. I'm a high school senior, and have written a book. The little girl who used to love going to the library is surprised. I've been able to work with the United Nations. The girl who loved watching politicians fight for world peace is beyond surprised. I've been able to meet people that I know will continue to support me in the future. The girl who sat in her room wondering if she would ever have friends is pleasantly surprised.

SHANNON WATTS

Founder of Moms Demand Action for Gun Sense in America

Born 1971 in Rochester, NY

When I was eight years old, my dad bought me a shirt that said, "Girls Can Do Anything Boys Can Do." What my dad probably thought was a moment of feminist allyship actually set off alarm bells for me: until that moment, I had no idea that anyone thought that that wasn't the case. It was 1979, and as an only child growing up in a middle-class suburb, I hadn't yet realized that girls were often considered second-class citizens in America.

I also happened to be bossy, rebellious, and stubborn, so at that moment I also decided that I would do whatever boys could do. I played soccer just seven years after Title IX was passed, I challenged the priest at our church who refused to allow girls to be altar servers, and I was the first woman on my maternal side of the family to attend college.

I also studied and learned from the women activists who hailed from my hometown of Rochester, New York: Hester Jeffrey, Susan B. Anthony, Helen Pitts Douglass, Fannie Barrier Williams, and more. School field trips to their homes or retracing their journeys made me want to be a leader and activist, too.

And then, in 2012, I followed their lead. I knew that if women organized around the issue of gun safety–just as they had around Prohibition to child labor laws to civil rights to the water crisis in Flint, Michigan—we would win. And I was right. Since the horrific shooting tragedy at Sandy Hook School, women and gun violence survivors and caring Americans—mothers and others—have joined Moms Demand Action and Students Demand Action chapters in all fifty states and made significant changes to gun laws and policies in statehouses and corporate boardrooms.

Women all over the world have always been the secret sauce for activism. When women get involved—particularly Black and Latina women—that's when we see real change. Women may not be making the laws that protect our families and communities—after all, we make up only 20 percent of Congress and 25 percent of state lawmakers—but we are on the front lines of activism in America, pulling the levers of power available to us to make real change. Polls show that women are more likely than men to support gun safety laws, and that the greatest growth in those views has occurred among women.

That's why we're showing up in statehouses across the country to create real change and pass comprehensive gun legislation. We've passed legislation requiring background checks in twenty-two states—most recently in Virginia; we've passed red flag laws, which allow the temporary removal of guns from people who are a danger to themselves or others, in nineteen states; and we've passed laws that help disarm domestic abusers in twenty-eight states. In addition, we have a 90 percent track record of stopping the NRA's dangerous agenda in statehouses every year for the past five years.

Women are also using their votes to create change, sending a clear message to the gun lobby. In Virginia this past cycle, Moms Demand Action volunteers out-worked the NRA by educating, canvassing, and turning out the vote on this issue. The NRA—which is headquartered in Virginia—lost big on election night. Both chambers flipped to gun sense majorities. Soon after, the legislature passed seven new gun safety laws and the governor signed them all into law.

Women are also voting with their dollars—they make the majority of spending decisions for their families, which is why dozens of restaurants and retailers have changed their policies to prohibit open carry after our volunteers put pressure on them. And gun dealers like Walmart and Dick's Sporting Goods have stopped selling firearms or ammunition to people under the age of twenty-one, and both retailers also no longer sell assault rifles and high-capacity magazines.

These changes by major corporations are another proof point that the tide has turned in favor of gun safety and should serve as a call to action for Congress. As the saying goes, it's mothers who brought you into this world, and they will vote you out—of your elected seat in municipalities, statehouses, and at the United States Capitol.

TRACY EDWARDS

Sailor, Author, and Advocate

Born 1962 in Pangbourne, UK

I was ten years old, tucked under the covers in my bedroom for the night, when I heard my mother scream. I knew something was very wrong. My beloved father had suffered a heart attack and died in our home.

I think somewhere deep down I have always been a fighter, or a "scrapper" (as I was labeled in school), but losing my father unexpectedly, then having my mother move us far away from everything we'd ever known and marry a man who wasn't very good to me seemed to put something into motion.

As a teenager and in my early twenties, I didn't fully understand my anger and many of the battles I fought were imagined slights from a paranoia of not belonging and a pervasive feeling of being on the outside of my life, looking in. Everything just felt hard.

But the first time I worked on a charter yacht, at the age of seventeen, the anger disappeared—almost overnight—and it was replaced with an overwhelming sense of belonging and knowing that I had found my path in life.

As far as I could tell, based on my limited life experience, there were no more fights to be had. What a relief it was. I cruised along for years, soaking up the happiness and camaraderie to be found while sailing in those days. That was, until I was bitten by the racing bug! I decided I wanted to do the 1985 Whitbread Round the World Race and understood that this was not a race women were welcomed into, so I jumped at the chance to be the cook onboard.

Yes, I hated the job of cooking for the men and I really hated the way I was treated, but at twenty-three, I didn't want to rock the boat, so to speak. I just wanted to be liked and allowed to join in with the boys because it was the boys

who controlled the sport I had fallen so madly in love with. If they wouldn't let me navigate—which was my passion—then so be it.

However, when I finished that race and realized that sailing wasn't a "phase" and that I would probably never be allowed to navigate on a round-the-world race boat, something inside me shifted. It was as if I had woken up!

I didn't feel sorry for myself at all, but I suddenly felt the full weight of the thoughtless, ignorant, inherent, crushing INJUSTICE of it all. This is the moment I realized I had to fight, not only for myself, but for all women. It is also the moment I realized that injustice is the battle ground, not just in sport, but in every single walk of life.

The sense of purpose I had while setting up *Maiden* and fighting tooth and nail for our right to race around the world with the first ever all-female crew to ever sail around the world, was to stay with me forever. The fight against injustice is my call to arms and my reason for being. *Maiden*'s huge (and unexpected, for the majority) success gave me a voice and I have spent every day since then, on a trajectory over which I have almost no control, as I use that voice to fight for others.

Maiden's spirit and mission continue today with the Maiden Factor Foundation, as she sails around the world again, but this time to raise funds for and support the right of every girl, everywhere, to an education. It is only when we have total equality in education, leading to equality in the workplace, at home society, and in government that injustice can cease to be. In my humble opinion, it is the absolute cornerstone of our very survival, and for that, I will fight.

BILLIE JEAN KING

Tennis Player, Author, and Activist

Born 1943 in Long Beach, CA

The moment I knew I was ready to fight for others, and for myself, all started with a question—"Where is everyone else?"

I was thirteen years old and had been playing tennis for just a couple of years when I found myself at the Los Angeles Tennis Club, the mecca of tennis in Southern California in those days. I was sitting in the bleachers when I started daydreaming about our sport and the impact it could have on others. As I looked around, I saw everyone wore white clothes, white shoes—in those days we played with white balls—and EVERYONE who played was white. I asked myself, *Where is everyone else?* At that very moment I knew I would spend the rest of my life championing for equality for everyone.

MARY L. TRUMP

Psychologist, Author, and Activist

Born 1965 in New York, NY

I was sitting on the couch with my foot elevated one night in September 2017, scrolling through my Twitter thread, MSNBC on in the background, as it perpetually was back then. It had been two months since I'd fractured the fifth metatarsal of my left foot and four months since Susanne Craig, an investigative reporter for the *New York Times*, had come to my door on a sunny day in June asking for my help with a piece she and her colleague Russ Buettner were writing.

"We believe you have documents that can help us rewrite the financial history of the Trump family," she had told me.

"I don't speak to reporters," I said, echoing a line I'd heard everybody in my family (except Donald, of course) say repeatedly since I was a kid. I continued to brush her off every time she sent me a letter or called me on the phone after that.

That night in September, however, having very little to do but watch the daily degradations and cumulative horrors of my uncle's administration unfold, I picked up the phone, called Sue, and said, "Okay, I'm in. Just tell me what you need."

What she and her team needed were documents from a seventeen-year-old lawsuit in which I had sued my grandfather's estate after learning I'd been disinherited. I had forgotten the documents existed, and I certainly didn't think they had any value, but these journalists felt differently. I was able to retrieve them from the law firm that had represented me all those years ago, and handed all nineteen boxes over to Sue.

My decision to cooperate, which felt more like a whim at the time, changed the course of my life. But in the moment, it didn't mean anything to me at all. Nobody

would ever know I'd been a source for the *Times*—I was merely doing my small part, anonymously, in order to set things right.

After that brilliant article was published a year later and eventually won the Pulitzer Prize, after my own book was published two years later and my voice was heard—how did I make meaning of one of the most consequential actions I've ever taken? My diffidence aside, this was clearly a pivotal moment in my life, after which literally everything changed.

Many people have asked me why I didn't speak out before the election of 2016, when it "could have made a difference." In order for me to have done that, however, with no proof of anything, only my own voice speaking truth to power, was to suggest I thought I mattered, was to assume I could overcome decades of learned helplessness, which was something almost everybody in my family had been burdened with. After suffering quietly on the sidelines of my father's family for most of my life, the idea of having real agency seemed absurd.

Sometimes it's easier to defend other people than it is to defend yourself. Sometimes you take the risk because you believe it's the right thing to do, and it isn't until much later that you can own the fact that it was also a self-empowering move—even if it takes having other people point that out to you.

Sometimes we can only own our power retrospectively. And that's okay, too.

ALICE PEACOCK

Singer-Songwriter

Born 1969 in White Bear Lake, MN

"Where was I when that happened?" My therapist, Yolanda, used to ask me this question when we'd meet to examine my latest poor decision. This meant: "Why didn't I think of the good work I was doing in therapy when I made this choice? Why did I let go of my healthy self?" She had a term to describe this state: "Action Alice," who intentionally tried to find ways to self-soothe when confronted with very human feelings such as loneliness, sadness, anger, and fear . . . usually, with not-so-healthy methods.

My mom and dad were religious and evangelical Christians; as a result, I had very little practice with forming my own opinions or developing any agency or trust in myself. They were also raised by individuals who struggled, on and off, with severe depression. My mother's mother was one step away from being homeless when she died; an alcoholic who ended up drinking herself to death in a squalid, roach-filled Los Angeles apartment. My other grandmother suffered from a narcissistic personality disorder coupled with paranoia and was a hoarder, her apartment packed to the gills with piles of newspapers, magazines, books, clothes, shoes, and plans for houses she'd never build and inventions she'd never see come to fruition.

I remember visiting my grandmothers as a teenager and vowing that I would never be like them. I had an aunt tell me during one of these visits that I didn't have to choose the beliefs of my parents; that, in fact, I could choose my own path in life. This was astounding new information! I knew that if I was going to escape the dysfunction of my family, I was going to have to do it on my own. I was going to have to fight for myself and my future.

I first went to see a therapist after I finished college, when I learned about some family abuse; I needed to unpack these revelations and see how it related to me. I remember starting off my session saying, "I'm not really sure why I'm here; I had a pretty happy childhood." I ended the session flooded with hot tears, convinced that the self-sabotage I was engaging in was going to lead me down the same path as my grandmothers. I saw my "endgame" in the most extreme light—a homeless lady, under a bridge, pushing a shopping cart, if I didn't get my act together. I continued to go to therapy for about ten years, finding a lovely therapist and mother figure who helped me investigate and shed light on my internal operating system—what my triggers were and how I could learn to self-soothe and cope in healthy ways instead of destructive ones. One healthy method I nurtured was songwriting. Writing songs was a way for me to process those "ugly" and uncomfortable feelings, and performing them brought me joy. When I doubted what I had to offer as a songwriter, a friend of mine told me, "Just write what you know. No one can say it quite like you."

I remember asking my therapist when I would be finished with all this therapy; would I ever "graduate"? I remember her saying, in words that still ring true to this day, that I would probably check in with myself throughout my life and that this was a good thing . . . a gift to myself because, after all, as she stated, "the unexamined life isn't worth living."

OLIVIA TROYE

National Security Professional and White House Official

Born 1976 in Reno, NV

I come from a lineage of strong women. My paternal grandmother, Gladys, was of Norwegian ancestry and raised thirteen kids—a feat that personally still amazes me. My maternal grandmother in Mexico, Benita, was tenacious and a fighter and trail-blazer in her own right, raising four children, including my mother, Marie. Marie, who is the pinnacle of my definition of strength solidified by the power of love, a giving heart, and kindness. My father, Richard, passed when I was in my twenties, and my mom and I were left to fend for ourselves. As a stay-at-home mom, who grew up in a household where females were seen as not needing to be educated, she got a job at a factory. It was hard labor, but it was how she would help support me while I navigated college debt, finding my way, and figuring out my career. I knew I would strive to be fiercely independent, and that it was up to me to protect us, to provide for us, and succeed. As a first-generation child of an immigrant, and a first-generation college graduate, I was at the beginning of my career at the time and no matter how hard it was to be apart, my mom was always my biggest cheerleader. I drew from the strength she had exhibited in some of our hardest moments. She says I was definitely a strong-willed child and a fighter from day one. I say, I got it from watching you, Mom.

My moment began in 2001, on one of the most tragic days for our country, 9/11. I remember being in the US Capitol when the first hijacked plane hit the North Tower of the World Trade Center. I ran back to my office, called my boss at the time, who was traveling, and looked at my colleagues, frightened and confused about what had just happened, as the additional hijacked flights would then proceed to crash into the World Trade Center, the Pentagon, and a field in Pennsylvania. We

were told to evacuate the building due to our close proximity to the US Capitol. Cell phones were down, and landlines were overwhelmed. My parents, down in Texas, worried for their only child, who unbeknownst to them would proceed to walk across the entire city to a friend's house to try and use her phone, then across the Memorial Bridge to Virginia, and all the way home. Five hours of walking amongst the gridlocked traffic, police barricades, military vehicles, and confusion, back to the condo I shared with my roommate, Ana. I walked home past the Pentagon engulfed by flames, emergency vehicles everywhere, and the sight of people crying all around me. I walked in, my roommate opened the door and started sobbing.

She said, "You're alive! I've been losing my mind wondering if you were okay." Like many Americans, we watched the news coverage for days in the aftermath. The images were burned into my head. I kept thinking about the pain and loss of loved ones, and processing what this meant for our country.

That moment changed the trajectory of my career, forever. I wanted to do more than political campaigning; I wanted to protect our country from national security threats. I wanted to fight for all of us. To think that every choice I made along the way would eventually lead me to an assignment in the White House seems unfathomable, but it would prepare me for the hardest decision I would have to make in the year 2020. The decision to give up everything I had worked for my entire life, my career, my privacy, the safety of my family, my well-being, and potentially my reputation, in order to continue to protect the security of this nation.

I served for over two years in the White House as the homeland security and counterterrorism advisor to Vice President Mike Pence. As the child of immigrants, a first-generation college graduate, and career national security professional, I felt a tremendous sense of awe and patriotism every day when I walked through the gates at the White House. It was the people's house, and I never forgot it. I never took a single day for granted. In the year 2020, an invisible enemy would change everything. The Covid-19 virus engulfed the world, impacting all of us, creating suffering, anxiety, pain, and loss. Our health-care and emergency front-line workers faced this enemy head-on, many without access to the proper protective equipment, and said farewell to loved ones so that they wouldn't die alone, apart from their families, who couldn't be there for their last breath, due to the severity of this contagion.

I worked fourteen-hour days (sometimes sixteen-hour days), seven days a week on the White House Coronavirus Task Force as the lead staffer and Covid advisor to the vice president during the pandemic, supporting a group of cabinet-level officials, medical experts, and scientists, such as Dr. Fauci, Dr. Birx, and Dr. Hahn. I rarely slept. I did everything I could to support this response effort, knowing that

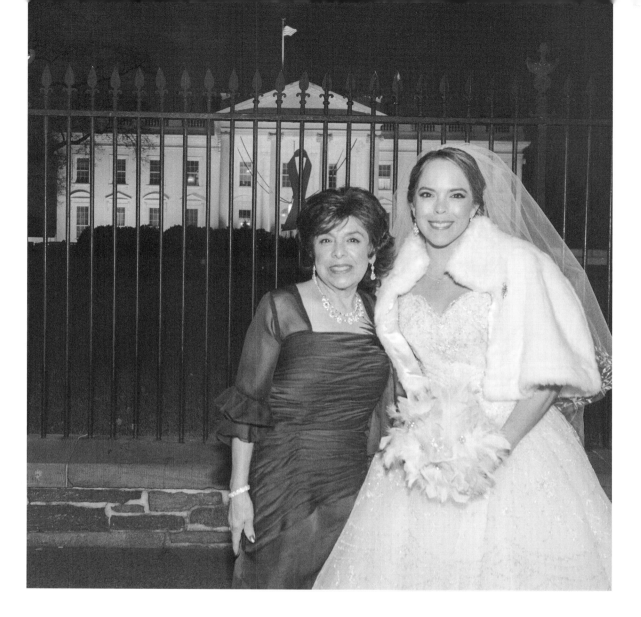

every minute, hour, and day mattered. I was hell bent on doing my part to protect the American people and save lives.

But in the days and nights that would come throughout 2020, during the largest pandemic of our generation, I would find myself in the center of the most politically charged environment that would push my moral boundaries and compass beyond anything I could have ever imagined. The pandemic response was driven by headlines and a president purposely downplaying the severity of the pandemic—

lying and spreading misinformation. A president focused on his own reelection prospects rather than protecting the lives of the American people. Millions of lives would be impacted, hundreds of thousands of loved ones would die. The dynamics of the political senior staff were an obstacle and challenge that became impossible for me to navigate and overcome. The scientific facts and data increasingly became distorted into lies to support a narrative that I knew would cost the lives of many more, and so I reached the breaking point and quit.

Not only did I quit my White House role, I left my career national security officer role as well, because I had to completely separate from everything I had lived, at times fought, and witnessed. And after walking away from it all, in this moment, I did something I had never done before. I spoke out publicly against the president of the United States; the most powerful man, some would say, in the world. A man who is known for being incredibly dangerous and vindictive. Like other patriots who had done so during the Trump administration, I found myself front and center with no safety net, with just my conscience and my integrity. In this moment, I had to do everything I could to fight for the sake and future of our country.

ALICIA SILVERSTONE

Actor and Activist

Born 1976 in San Francisco, CA

The bullying most people talk about is the overt kind—the mean and loud criticism of a tabloid or middle school recess fight. But the bullying I saw as a child that ramped up my inner fight was the subtle, quiet, accepted oppression of speciesism and the way that humans claim dominion over the animals we share our planet with.

My mom and I used to run up and down the highway rescuing stray dogs whenever there was one on the loose. When I look back now on those first direct activism actions, I realize those moments locked in my mission to advocate for the defenseless, even if we looked like total nuts running on a highway after terrified dogs.

It is not until we can fight for the innocent that we can fight for ourselves. Becoming an activist taught to me speak up, even if my voice quivered. It allowed me to stand up against all injustices, effortlessly, because it simply was not about me—it was about the voiceless, oppressed, and disenfranchised. My fight for myself came from fighting for others.

KYLE SMITLEY

Founder of the Detroit Achievement Academy and Cofounder of Detroit Prep

Born 1985 in Defiance, OH

"The education system is broken, there is nothing you can do."

"Detroit is too dangerous. You don't want to live there."

These are the words that echoed in my San Francisco circles after selling my company and setting my sights on Detroit. I realized it would take someone incredibly tough and determined to create the schools the Detroit community deserved.

My moment came when I realized I couldn't wait around for that person anymore.

It was me.

"She has no idea where to even begin. She should not be allowed to open a school."

"These kids are just too poor to achieve at high levels. She is setting herself up to fail."

These words, from "Detroit education experts," really stung at the time.

So I started from scratch. I created recruitment plans, appealed to teachers eager to move back but looking for a special school, set my vision, signed a building lease (and rented a house two blocks away), and dreamed up what it might look like to have the best schools in Detroit.

It was only after working myself to the bone planning, working, hustling, and building that I realized that the greatest schools are created by the greatest teams. Nothing was going to happen without a community of Detroiters who have always held this dream as well.

It was them.

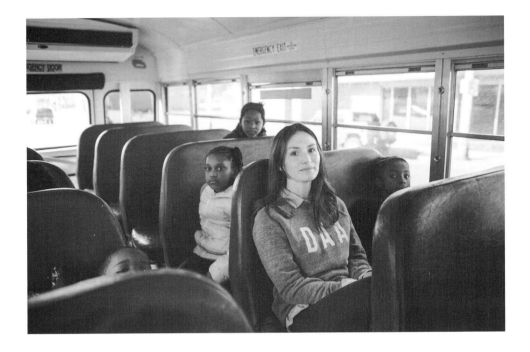

Together with the most incredible greatest staff on earth, we opened our first school, Detroit Achievement Academy, in 2013 and our second, Detroit Prep, in 2016. They're the two best schools in Detroit, and both have hundreds of students enrolled and hundreds more waiting to get in. My team and I worked so hard, overcame obstacles using compassion, perseverance, and integrity, and we successfully created a joyful, rigorous learning environment.

I will no longer let people tell me what a city is capable of, what a child is capable of, or what I am capable of.

SHERYL CHINOWTH

CEO and Cofounder of Chinowth & Cohen Realtors
Born 1955 in Alton, IL

At sixteen years of age, I was an honor student. In high school, my counselor and teachers told me I could qualify for a scholarship. All I needed was one science class and one foreign language to qualify. I signed up for chemistry and French. Not all men of my father's generation believed their daughters should go to college. For me it was my destiny. My father changed my chemistry and French class to homemaking and typing because he thought I would someday make a great secretary. I went to college anyway. I used those typing skills when I worked for a dean, which helped me offset three years of my tuition at the college.

Several years later, married with a nine- and two-year-old and selling lots of real estate, my husband came home like he did every evening to dinner on the table. He walked through the door, packed his bags, and left.

These moments made me stronger and made me realize I needed to stand up for myself. I learned that so many people struggle and have major disappointments in their lives. I learned I wanted to make my life better and be stronger so I could improve as many lives as possible while on this earth. I live by it day by day and nothing has made me happier.

CYNDI LAUPER

Singer, Songwriter, Actor, and Activist

Born 1953 in Brooklyn, NY

Growing up, I heard a lot of life stories about dreams denied, from the women who raised me and from the women in my neighborhood. My mom had a great voice. So good that she was even given a scholarship to one of the arts high schools in New York City, but she wasn't allowed to accept because my grandparents said, "Only whores go to school in Manhattan." On weekends and time off she was expected to do housework. Women weren't supposed to have careers, let alone dreams. They were to go from their family home to their husband's home. They went from being someone's daughter to being someone's wife, like chattel. In the end, my mom got so dispirited that she got sick and wound up not even finishing high school. I heard and saw similar stories again and again growing up in my neighborhood. Dreams, not just dashed, but trampled. So, I didn't have "a moment" so much as a lot of "moments" growing up around these brilliant, talented women. I was not going to have the same fate. In the neighborhood I came from, everyone always said, "I coulda been this, I shoulda done that," but they never did. Well, I made sure I did—that I wasn't one of the "shoulda, coulda, woulda" people. I was going to win, not just for me, but for all of them.

As an artist, I thought that maybe I could do something and say something so loud that every girl would hear—every girl, every color, every nationality, from all walks of life. And I said to myself, "Hell yeah, I'll make an anthem! Maybe it'll be something that will bring us all together and wake us up." It would be a movement right under all the oppressors' noses and no one would know about it until there was nothing they could do to stop it. I was going to make it work come hell or high water. I'd make it work for every poor sucker whose dreams and joys were dashed out. When I sang "Girls Just Want to Have Fun," it was their faces that filled my head.

PEPPERMINT

Actress, Singer-Songwriter, Television Personality, Drag Performer, and Activist

Born 1980 in Hershey, PA

Some of my earliest memories were peppered with hesitancy and fear of isolation. I didn't see a lot of people who looked or acted like me anywhere. I was often encouraged by friends and family to focus on my uniqueness. While they were right, I felt utterly alone.

As I got older, criticism of my queerness, swishiness, and my individuality expanded. Harmful words turned to harmful actions. A lot of my late teen and early adult years were spent strategically evading opportunities for other people to access my vulnerability. If there was a group of boys on the street, I would walk ten blocks out of the way to avoid them. I made it a point to no longer get up in front of a crowd in school or in public, even though being in front of a crowd and performing is my first true joy. I remember being beaten up in high school and instead of challenging or standing up to the bully who was about my size, I just bowed my head and walked to class, bruises and all.

I've always had a strong sense of who I am, but wasn't sure how to connect that to the outside world. I wasn't able to see my value reflected back to me in other people's eyes. I felt isolated and unable to fight back or stand up for myself . . . until I found community. A chosen family, a stronger reason to connect with people and even fight on their behalf. I was able to fight for other people whom I love, and I know love me. I'm loved by people that I'm sharing space with even though I've never shared space with them before. This sense of community is what gives me permission and fuel to fight for myself.

YASMEEN HASSAN

Global Executive Director of Equality Now

Born 1969 in Boston, MA; raised in Lahore, Pakistan

Growing up in Pakistan, I had learned three critical lessons by the age of ten that inspired me to stand up for myself and other women.

First, that *girls were considered inferior to boys*—births of boys were celebrated, while births of girls were often mourned. When my mother was pregnant for the second time I wished for a "pink baby sister" and my paternal grandmother told me that this child had to be a boy—I remember asking, "But why?" It is a question I am still asking!

Second lesson was *the power of organizing*. In preschool, my friends and I were thrown off the swing sets (the most coveted playground equipment) by boys who were bigger and stronger (though dumber) than us. We realized that if we banded together we could take back the swing sets—and we did!

Third, *the critical role played by the law*. The defining moment of my life came at age ten when a military dictator "Islamicized" Pakistan's laws, effectively making women second-class citizens. Women could not sign financial documents on their own, the testimony of two women in court was equal to that of one man, and, worst of all, if a woman was not able to produce multiple male witnesses to her rape, she could be flogged for fornication and adultery. I saw women take to the streets in protest and the government tear gas and imprison them. I understood instinctively that the suppression of women led to fear, insecurity, and conflict in society.

These experiences set the course for my life as a lawyer and now as the global executive director of Equality Now, a human rights organization dedicated to promoting the rights of women and girls around the world.

CHELSEA HANDLER

Comedian, Author, and Activist

Born 1975 in Livingston, NJ

I didn't learn about fighting for myself until I found out I was so good at fighting for other people. Sometimes it is easier to stick your neck out for others, but I have learned that if something is not good enough for your sister, mother, niece, or best friend, it certainly is not good enough for you.

MJ RODRIGUEZ

Actress and Singer

Born 1991 in Newark, NJ

The moment I realized I was ready to fight for myself was at the age of seven. It was then that I had the conscious thought that I would need to speak up, make my own decisions, and take action in order to protect myself. Once I told myself, *You're not the one catching up with the world, the world needs to catch up with you,* my movement of love, inspiration, hope, joy, and last, but not least, justice, went into effect—and to this day it has not stopped. It will continue until we reach some form of peace.

JUDY MAYFIELD

Social Worker and Feminist

Born 1944 in Levelland, TX

I felt inferior all during my small-town Texas childhood. My father had deserted the family when I was seven years old, my mother was uneducated and had three young children to feed, and we lived hand-to-mouth in a run-down part of town. I was embarrassed to bring other kids home with me, so made up all kinds of elaborate excuses so they wouldn't know where I lived. We attended a fundamentalist church that was very judgmental and exclusionary, and the congregants were taught that we were undeserving and "no better than worms." In the church, women of all ages were to subjugate themselves to any male age twelve and up (women were not allowed to even teach Sunday School to boys who were twelve and older).

My mother scraped (I had the good fortune of being the youngest, so the last in the home), and with the help of loans and scholarships, I was able to attend college. Unfortunately, the university was closely tied to the same judgmental, narrow-minded denomination in which I had grown up, and it further reinforced that women were deeply inferior to men and that we were ultimately destined to be only wives and mothers. It also stressed that people outside the denomination were doomed to hell. I was on campus when John F. Kennedy was assassinated, and there was great rejoicing—among both students and faculty—about his death being "God's will" since he was Catholic.

I married right out of college, and my new husband joined the military. Our first station was Great Lakes Naval Training Center in Waukegan, Illinois, not far from Chicago. Was this an eye-opener for me! I worked with people of many different races, cultures, and religions, and with those who saw politics and society as a whole from a totally different vantage point than I. Most people there were open,

opinionated, and inclusive. Long story short, I began to come into my own. I became a "card-carrying" feminist, a member of Chicago NOW (NOW was considered such a subversive organization in 1971 that we later learned that the FBI kept files on us), and threw off the shackles of my religion and its sexism (my husband did not, so we had irreconcilable differences).

When we returned to west Texas, I found I had many battles to fight. I got a divorce, but first had to establish credit in my own name as a married woman (even though I'd been the major wage earner for many years), as single women were routinely denied credit. I battled with the local newspaper, whose help wanted ads were segregated by sex. I marched for abortion rights and for the Equal Rights Amendment. One day, while listening to the radio, the local announcer said the singer Connie Francis had been raped (this had been a brutal assault that occurred at knifepoint). He laughed, adding, "Now she knows 'Where the Boys Are,'" and played the song (which had been one of her greatest hits). Outraged, I called the station, insisted on speaking with the manager, who, obviously taken aback at my tirade, finally weakly apologized.

I had found my voice, and there was much work to be done. No longer was I that insecure little girl who tried to mold herself to others' expectations. Many women were having similar awakenings, and, in 1974, I cofounded the Lubbock, Texas, chapter of NOW. For many decades, the chapter was a vibrant, meaningful organization in the city that was instrumental in not only raising the consciousness of many women and men, but in effecting lasting change in my conservative community. And I've tried to pass that voice on to my two daughters, who are adults now and strong feminists. Becoming aware of my own power totally changed the trajectory of my life.

SHARON DIAMOND

OB-GYN

Born 1949 in Bronx, NY

I was sixteen years old, ending high school and living with my parents in the Bronx, when my great uncle came to visit from Chattanooga. I adored him. He was a larger-than-life figure who had rescued Jews fleeing Nazi Germany and sponsored them in his businesses. We saw him infrequently and every trip was special but this one was different. On the first night of this visit, the evening news reported that a thirty-nine-year-old civil rights worker, a "housewife" and mother of five had been murdered in Alabama. Her name was Viola Liuzzo.

As a young white teenager living in New York, I was increasingly aware of the struggle for equal rights. I'd begun joining protests against the segregation of city schools and was developing a growing understanding of the inequities of the education, economic, and social systems that handicapped young children of color.

As I was struggling to comprehend how someone could be murdered for fighting for what was so clearly right, my uncle spoke. "If she had stayed home where she belonged this wouldn't have happened. She was asking for trouble." He ranted on, uttering racist epithets.

I was bewildered. How could my beloved uncle, who had escaped murderous antisemitism in Europe, adopt such a bigoted ethos? It felt like a personal attack. I had been taught to respect my elders but my bewilderment turned to fury. I screamed at my uncle, words of pure unbridled hurt and rage.

Subsequently the experience led to intense self-reflection. That night was a turning point for me. I already knew that the civil rights fight was in the streets; now it had arrived in my living room. Being told by my own uncle that a woman's place was confined to home and that I had no right to engage in "a man's world"

inspired in me the desire to do just that and the conviction that I could help change it from "a (white) man's world" to a world for all peoples. I knew that I would fight for myself which would of necessity mean fighting for others.

Viola Liuzzo, and my uncle's response to her death, sparked in me the urgent desire to engage more deeply in social and professional activism. After a circuitous route that included civil rights marches and social work, I enrolled in medical school and went on to become an obstetrician-gynecologist. I have been blessed to be in a profession that allows me to be involved in women's lives throughout their life cycle. From encouraging a young teenager to stand up for herself in beginning relationships to counseling older women on how to extricate themselves from abusive ones, I have hoped to have a positive influence. In educating women of all ages about their bodies, and encouraging them to feel good about themselves, I offer a counterpoint to the narrow cultural view of

female beauty. In discussing school problems as well as workplace issues I strive to help women believe in themselves and in their agency in the world. In my work I continue to fight for women and hope to inspire women to fight for themselves. By fighting for women, I fight for myself.

HAVANA CHAPMAN-EDWARDS

Student and Activist

Born 2011 in Cairo, Egypt

The moment when I first realized how powerful my voice can be was when I participated in the National School Walkout in 2018 when I was seven years old.

The National School Walkout was on April 20, on the anniversary of the Columbine shooting when twelve students and one teacher were killed at Columbine High School in Littleton, Colorado.

The plan for the National School Walkout was for students to walk out of their classrooms and observe thirteen seconds of silence in memory of those killed at Columbine.

Even though Columbine happened a long time before I was born, I still had a connection. At the school shooting in Sandy Hook, the kids who died were first graders just like me. The issue of gun violence is personal as well because my cousin Tony was shot and killed when he was only seventeen.

We were supposed to wear orange to honor the victims of gun violence, so I chose to wear my orange astronaut suit. I wore it because I want to be an astronaut when I grow up, but also because it reminds people that I have rights, but that I also have dreams.

When I realized that I was the only one at my school to walk out, I was heartbroken. Then we used my mom's phone to look at the live

news of all the other kids walking out of their schools, and I felt better and didn't feel alone anymore. After we finished our moments of silence, I wrote a tweet saying, "I am alone at my school, but I know I am not alone," and shared the picture of me in front of my school.

I went back in for the rest of my math class, and by lunchtime, my tweet had gone viral. I left school early to do interviews on the news, and even a live interview on a Canadian news channel. I also had real astronauts like Dr. Mae Jemison and Mark Kelly tweeting me that they were proud of me.

One of my sheroes, Malala Yousafzai once said, "When the whole world is quiet, one voice becomes really powerful." When I walked out of my school, I felt brave and powerful. I knew then that other kids watching me might feel more brave and powerful too.

After that day of the walkout, my whole world changed. The most important lesson I learned that day and ever since then is that bravery is a muscle and you are never too little to make a difference. Since my parents are diplomats, we move to different countries every couple of years and I see firsthand how the world is connected. I have continued standing up for myself as well as others because whether you live in Germany or Australia, the United States or Senegal, we depend on each other and we can't make the world strong if we leave people behind.

Imagine if all one hundred million girls around the world who don't have access to school also had the chance to lead their communities in a national walkout or a march. Imagine if those girls graduated and replaced the world leaders who have ignored us.

Like my forever first lady, Michelle Obama, says, "The future of our world is only as bright as our girls." The future belongs to all of us. Even those of us who are too small to see over a podium. My name is Havana, also known as The Tiny Diplomat, and I choose to be a tiny revolution day after day after day.

BECCA STEVENS

Author, Speaker, Episcopal Priest, Social Entrepreneur, and Founder/President of Thistle Farms in Nashville

Born 1963 in Milford, CT

My moment was the day I hit Michael Heard in the face on a South Nashville playground in third grade.

My father had been killed by a drunk driver a couple of years before, which had left my mother financially strapped and raising five kids on her own. By the time I was eight, I'd endured more than two years of being molested by an elder in our church. So, one fall morning when the dust was dry and the air noticeably thin, I saw Michael picking on another kid . . . kicking dirt into her face. I couldn't stand watching it happen so I hauled off and started fighting him. I didn't even know I knew how to fight like that. I think we were both shocked.

Although I didn't realize it then, in that moment—sticking up for an underdog—I was fighting for myself.

I don't get into fistfights anymore; in fact I'm a pacifist, but I have continued to fight for others my whole life and that practice has been inextricably connected to learning how to stand up for myself. It has been my saving grace and my path to freedom.

I would go on to found a sanctuary, more that twenty-five years ago, to fight alongside survivors of trafficking, addiction, and prostitution. But even after I'd opened the doors of the first Thistle Farms home for women, something inside of me was still unsettled. I needed to confront the man from our church who'd abused me as a little girl.

I summoned the strength to call his wife and ask for a meeting. I sat down with her and my abuser at their home and began, "I have a story to tell. . ." The first question he asked me was, "Who else have you told?" From there, it was a painful, hard, and honestly powerful road for everyone.

Thistle Farms has grown into a global movement for women's freedom; working with thousands every year. We even opened a café in Nashville that honors and employs survivors.

In 2019, a thirty-five-year-old man walked into our café looking for me, as I am the public face of Nashville's preeminent safe-haven for so many who struggle. He bore a striking resemblance to the man who'd molested me and he was about the same age my abuser had been at the time of the abuse. I greeted him and when he told me his name, I knew very certainly that he was my abuser's grandson. I steadied myself so I could remain present. I stood face-to-face with him, twenty years his elder, but vividly remembering what the six year-old me felt like all those years ago; powerless to stand up for myself in the presence of a mean, abusive man.

As his grandson told me about the troubles he had faced in his own life and that he'd come to see how he could help Thistle Farms, I knew I could stand up for him too. He didn't know it was his grandfather's abuse (which began almost fifty years ago) that led me to fight Michael Heard or to build my life around lifting up the vulnerable. And that's okay with me.

What I do know is this—once we take a stand for love, it is inevitable that we will encounter people and experiences which can allow healing to occur. Sometimes it takes generations, but fighting for love is the most powerful force we have—for the whole world and for ourselves.

And by the way, Michael Heard and I ended up being friends.

MEENA HARRIS

Lawyer, Children's Book Author, Producer, and Founder of the Phenomenal Woman Action Campaign

Born 1984 in Oakland, CA

I sometimes joke that I grew up a little like the opening scene of the Wonder Woman movie: surrounded by a community of smart, strong, phenomenal women who ran around saving the world and helping one another succeed.

The women who raised me—a hardworking single mom, an aunt who showed me the meaning of public service, a grandmother who taught me I should try to make a difference, big or small, in everything I did—instilled from an early age that I'd *always* have to fight for myself. That's what they had done all their lives. So that's what they taught me from almost the moment I was born.

When I was about four years old, I remember going to the grocery store with my grandmother. It's one of my earliest memories; I can still hear her explaining, to my great disappointment, why we weren't allowed to buy grapes. It was 1988. Caesar Chavez was fasting to call attention to the plight of farm workers and their families. And my grandmother taught me two important lessons at the supermarket that day.

The first was a new vocabulary word: "boycott." The second was a deeper truth, one that has shaped my life ever since: that fighting for myself never means *just* me.

She taught me I wasn't just a *product* of that community of phenomenal women, I was a *part of it*. Which meant I'd always have a responsibility to bear up the people around me. To fight for my community just as hard as my community had fought—and continues to fight—for me.

Since that day in the grocery store, Cesar Chavez, who already was a hero to

the entire state of California, has been a hero of mine, too. But I've also become inspired by the woman who fought beside him all those years, and who still fights to this day for women's rights, immigrant rights, and racial equality: Dolores Huerta. She once said, "Every moment is an organizing opportunity, every person a potential activist, every minute a chance to change the world."

Not all of us are activists. None of us can do everything. But all of us can do something.

And when we come together? When each of us does our small part?

Every single minute becomes a chance to change the world.

SHANNON JUBY

Pilot, United States Air Force

Born 1973 in Parma, OH

I have lived a fortunate life. When I think about the many incredible opportunities I've been given, it would be crazy to not list high among them the fact that I was one of the first handful of women to fly the F-16 for our United States Air Force. But I can sincerely say, while that was certainly a distinct honor, my greatest achievement—the thing of which I am most proud—is helping others be the absolute best version of themselves.

When I arrived at my first duty station, Cannon Air Force Base in Clovis, New Mexico, the attention I received just for being the first female to fly the F-16 at that location made me uncomfortable. I was among many dedicated, tenacious

fighter pilots who were committed to doing their very best for our country and I shared their aspirations. I simply wanted to blend in and find my place among my peers. However, since women had only recently been authorized to fly combat aircraft, I began to receive invitations from the local community to speak about my experience. Initially, I politely declined them all.

It was 1998 and at that time, there were still skeptics about women in combat—especially in the cockpit of a fighter jet. They had questions like, "What would happen if a female pilot was shot down in enemy territory?" or "Is she even a good enough pilot to accomplish our combat

mission?" I was well aware of their concern. I'd heard some conversations and although I knew my comrades liked and respected me, I could feel some of their doubt. Yet, this paled in comparison to the pressure I put on myself to be the best fighter pilot. I knew I was under the microscope and that any mistakes I made would be amplified. As such, I had an unrealistic expectation of myself to be perfect.

Fortunately, a friend of mine who was a public affairs officer pulled me aside one day to readdress the invitations to speak that I was still regularly declining. She understood my thinking and respected where my focus was at that time, but she offered her thoughts on the bigger picture.

"Maybe it doesn't have to be about YOU," she explained. She reminded me that by merely being there in uniform in the classroom, the young female students would see, right before their eyes, that anything is possible. Her words resonated with me and not long after our talk, I was invited to speak at a local elementary school. I accepted that invite and much to my surprise, I loved it. From that point forward, I could not get enough of the kids in the classrooms. I was hooked!

Of course, the students didn't share the skepticism about women in combat roles, but they did have questions and observations of their own. "How do you go to the bathroom in the jet?" and "Your helmet is really cool!" I began to accept invitations for other forums like local college career days, Rotary Club meetings, chamber of commerce functions, and the like. I mentored sons, daughters, friends, friends of friends, new military recruits, officers-in-the-making, and so many more. With each event and with every connection made, my confidence soared.

And over the years, through the course of those speaking and mentorship opportunities, I came to understand something really important. I learned that I don't have to be perfect—that I am more than enough. As I sought to educate and inspire others to be the best versions of themselves, I became the best version of myself; both in the air and on the ground.

Being an F-16 pilot afforded me the chance to serve my country doing some-

thing I truly loved and in my twenty-five years of active-duty service, I have always embraced one of our Air Force's core values "Service Before Self." Yes, sometimes "service" means going to war—which I have—and being prepared to lay down your life. But for me, it also means encouraging children to dream big and inspiring adults to do more than they ever believed possible. Paving the way for others, empathizing with them as they face inevitable defeats along the way and celebrating their accomplishments and their victories is what I was born to do.

I also happen to be a pretty decent fighter pilot, too.

AMIKA GEORGE

Author and Activist

Born 1999 in North London, UK

Everything changed one morning in April 2017. Eating cereal at my breakfast table before school, I spotted a news article on my phone about "period poverty" in the UK. The term was entirely alien to me, I'd never even considered what I might do if my family hadn't been able to afford period products. A quick Google search unleashed numerous reports of girls in Britain missing up to one week of school every month, or using horrific alternatives like toilet paper, socks, or newspaper, instead of pads or tampons. I couldn't believe it.

Period poverty was hitting the very poorest families in the UK, who had to choose between eating and staying warm. Menstrual care was simply not a priority. Missing school meant these girls were compromising their educational attainment, their ambitions for the future, and the chances of escaping from the clutches of poverty for future generations. They were facing isolation, stress, and loss of dignity.

I waited for a swift and decisive announcement to come from the government, announcing free provision for those who needed it, but despite the gasp of horror from those in power and some media coverage, nothing came. No help was offered.

I don't know why I thought I could be the one to do something, but something stirred in me. Some kind of jolt within my brain pushed me to look beyond the four walls of my comfortable bedroom, to put myself in the shoes of those girls who were too poor to have a period. They couldn't and mustn't be forgotten. That was the recurrent thought in my mind.

That evening, I started a campaign called Free Periods, asking the British government to pledge free menstrual products for all children in full-time education.

The next two years, campaigning against the government's inaction, weren't easy. It was one continuous loop of writing to politicians, arranging meetings with them after school, giving talks, writing articles, and doing interviews, trying to persuade people to care, and to keep period poverty alive in the public consciousness.

In December 2017, the Free Periods protest saw over two thousand young people gather in London, to demonstrate our collective outrage and shout about the government's silence on period poverty. People of all ages and genders assembled, dressed in red and waving banners emblazoned with period puns. As they chanted, "What do we want? TAMPONS! When do we want them? SOME TIME THIS MONTH!", it was beyond clear that the cry for change was loud and irrepressible. In January 2019, nothing sustainable was pledged by the government, so I began to work with lawyers to prepare a legal case urging for an end to period poverty in schools.

Today, this is a reality. From January 2020, the government has given funding to every single school in England for the provision of free menstrual products for their students. Now no one has to miss school because they can't manage their period. No one has to fashion makeshift period protection from old rags. No one has to go through the monthly stress of wondering where their next pad will come from. Periods will no longer hold us back.

But there's still work to do. Free Periods has now grown into a global movement, and passionate teenagers are fighting for an end to period poverty in countries across the world. I'm determined to use the platform that I am so privileged to have been given, to speak out and educate further, and to collaborate with organizations, charities, and campaigners on the ground. I believe that we must take very clear and decisive action to encourage governments to understand that, among myriad other benefits, ensuring free or affordable access to period products in schools is an investment in education, in equality, and in the future of young people everywhere.

For too long periods have been bound up in a patriarchal taboo, associated with dirt and disgust, with fear and impurity, and this needs to change. There is an en-

trenched culture of shame and secrecy, which perpetuates gender inequality and silences the experiences of those who menstruate. Free Periods is working harder than ever to erase that stigma, by encouraging open and honest conversations around menstruation, with language that is empowering and inclusive, to end the oppressive silence around periods that our society has normalized.

In an uncertain, unequal, and increasingly volatile world, young people especially are raising their voices, creating new, innovative forms of protest, and mobilizing their communities to take a stand. They're using social media and the internet to influence those with more traditional forms of political power. My generation has proven that we are resilient and determined to fight social injustices, and call out the inaction of politicians whose priorities seem distant and detached from our own. Above all, Free Periods has taught me that activism really can change the world. That's why I believe everyone can, and should, be an activist.

DORRIS WALKER-TAYLOR

Senior Ambassador of Community Relations at Thistle Farms and Advocate

Born 1956 in Springfield, TN

I awoke one morning in a community of women that were ready for a new way of life.

I realized all my attempts, all my life, had failed.

I knew I was ready to try again and just see what happened.

THEN . . . Early one Saturday morning, just as I opened my eyes, all my mistakes, fears, and inhumane treatment came into focus and I was reliving the most disgusting parts of my past.

Were the figures on the popcorn ceiling really moving and appearing before my eyes as little balls of crack cocaine? It startled me at first, because I was only two years clean after the long twenty-six-year battle with addiction, abuse, selling myself as though I was some type of a commodity. My trauma begins at age twelve after witnessing my father's murder. As my dying father fell to the ground, I was partially trapped underneath him. My terror reigned for twenty-six long miserable years.

Then suddenly, all the massive numbers of assailants, rapists, johns, tricks, dirty cops, and all the categories in which men could be placed in, began to flash one by one through my mind. The hitting, the releasing of himself onto my body, usually my face, poured in like a violent storm.

If seeing the crack on the ceiling and vividly remembering horrific sex acts performed on me without my consent wasn't enough, I suddenly heard a very loud gunshot. I jumped so hard that it felt like I was back in 1968, it felt like I was twelve years old again, it smelled like blood in the air all over again. I began to

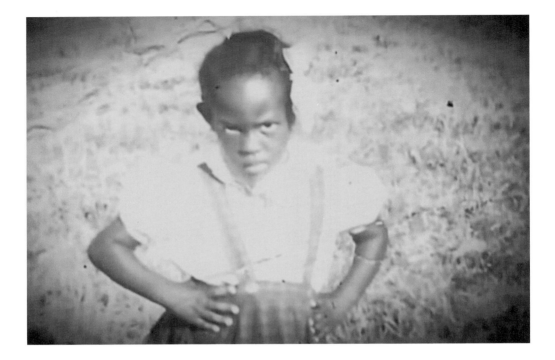

shake, and sweat, and cry, and lose control of all my tools that I had learned from my therapist at the sexual assault center. I was forgetting to center myself and BREATHE. My twenty-four months of training was slipping away as my body began to shake and my nails began to dig deeply into the palms of my hands until the pain, yes, that familiar feeling of pain, began to make me crave my old life, the life I had lived in shame for as long as I could remember.

When I suddenly realized that I had blood running down my arms, I became weak, silent, submissive, ready to serve that strong hold of addiction once again.

This was my cue to run, to grab my coat and shoes and head out to find a chemical substance to soothe my soul until I was numb again, feeling nothing.

Jumping to my feet, a sudden calmness came over me, and I remember shouting at the top of my lungs, "IS THAT ALL YOU GOT?!"

Your power over me has lessened because I have found a new way of life and a

new way of coping. Yes, that's right: I read that prayer was the most powerful tool that we possess.

I thought I was about to fall to my knees in prayer but instead I stood upright screaming, "*I will not be tormented by my past because God has forgiven me of all my sins, which are many.*"

Now I am no longer an addict, no longer a prostitute, no longer trapped in a ten-block radius. I am the daughter of the highest God.

I found my voice; I could say NO for the first time in my life.

For me, music is food for the soul. So I began to rock and hum a silent prayer. I began to sing a song that was all too familiar, *Oh Lord I want you to help me.*

I showered, called my therapist, went to a meeting full of folks just like me, and moved forward in my life. I will forever be grateful for my eleven years of sobriety.

Forever grateful for the introduction to Thistle Farms through Becca Stevens.

Forever grateful to be able use my past as a confirmation to others that we do recover.

Forever grateful for the chances given to me to use my words to heal and not be destroyed by words that used to tear me down.

Forever grateful for the moment in my life when I realized I was ready to fight for myself.

EMILY SALIERS

Musician, Songwriter, Author, and Advocate

Born 1963 in New Haven, CT

Honestly, I've never thought about fighting for myself, but I have come to know, hear, and listen to my own voice, which may be the same thing. There wasn't a moment, but there has been a period of time, only because I got sober, over the last few years where I am clear about what I value and what I will stand up for.

The moment I became a mother was the moment I knew I could die for someone else.

JANN ARDEN

Singer-Songwriter, Author, Actor, and Animal Advocate

Born 1962 in Calgary, Canada

I spent much of my adult life in denial about my abusive use of alcohol. It's hard to think about what I put myself through—what I put my heart and soul through—but I know I can't dwell in what was. I didn't expect sobriety to be so profoundly life-changing. In fact, I thought my life would be dull and uninspiring if I couldn't drink.

I couldn't have been more wrong. When you find yourself again, after decades of not being authentically true to who you are, it's exhilarating! The things I have been able to accomplish astound me. My ability to be thoughtful and kind and understanding grows with each passing day. Sobriety really is my superpower. I didn't know how far away I'd gone from who I was until I stopped drinking. That day in August four years ago, I stood up and never sat back down. I stood up for my happiness and my joy and my bliss, and I've never looked back.

CELIA BELL

Photographer

Born 1984 in Carlisle, PA

On January 11, Mama passed away. My nervous breakdown began January 17. My mind was a broken movie reel, replaying moments that lead to her death: her hand squeezing mine as I birthed my son into the world. Her arms around me the nights I laid with her, wondering if it was the last time. I couldn't sleep, I couldn't eat. My muscles ached from carrying bones that felt like lead. The heaviness on my chest wrung all the air from my lungs. My head throbbed, caught in a storm of memories, and I was drowning. It had been one year of hospital visits and twice-a-week drives to Boston. One year of radiation and false hope of a stable tumor. One year of middle-of-the-night ER trips and praying for a miracle. One year of choosing between my son and my dying mom.

Every symptom mutated into my own terminal illness—heart palpitations, shortness of breath, tingling on the left side of my body all landed me in urgent care waiting rooms and specialist offices looking for an answer.

But there was nothing.

And a few days after Mama's funeral—after we came home, after I laid my son down for a nap, after I gathered my family's dirty clothes for washing—I collapsed on the laundry room floor.

Splinters of light spilled across the dark room where I lay with piles of laundry around me; I cupped my face in my hands and rocked on the cold floor. *I'm not okay*, I said over and over again. I wasn't ready to say goodbye. I wasn't ready when the doctor said *brain cancer*. I wasn't ready when her hair fell out in clumps and I hid it behind my back so she wouldn't see. I wasn't ready when she stopped speaking, when she couldn't say she loved me anymore. I wasn't ready when the doctors

asked permission to give chest compressions. I wasn't ready when they put her into a body bag and zipped it closed. I wasn't ready to bury her, to live my life without her.

And now I stood on the edge of a cliff. I could take one step and tumble into that endless pit; I could lose myself to it. Or I could find the courage to fight.

It's been one year since I stepped back from that ledge on my laundry room floor. One year of choosing the courage for twice-a-week therapy visits and anxiety medication. One year of midday meditation and early-morning tai chi. One year of diving deep into my art to process heartbreak and anguish. One year of slow walks down a dirt road, feeling my son's small hand wrapped around mine. One year of lying in bed, scared to face this new life without her—but choosing to get up anyway.

For the great storms of our past will challenge us; they will shape us or break us. We can succumb to the fear and bury ourselves in the wreckage they leave behind. Or we can dig up the courage from within us and fight for our future. Because having courage doesn't mean you aren't afraid; it means you persist despite your fear.

STACEY TOPKIN

Creative Agency Partnerships Director

Born 1969 in Brooklyn, NY

Like most, I've fought through difficult times. Losing my aunt at nineteen, coming out of the closet at twenty-eight, and the earth-shattering death of my mother from ovarian cancer at thirty, to name a few. But I'll tell ya, facing my own mortality at forty-three was a battle I wasn't ready for, but not fighting meant death.

In October 2008, at the age of thirty-nine, the universe aligned and I met the love of my life, Hannah. She was the most hilarious, smart, kind, and gorgeous woman I'd ever seen. They say, "When you know, you know," and we just knew. We fell madly and deeply in love, became engaged in August 2011, and planned a wedding for December 2012.

Though we lived in Atlanta, we decided to marry in New York, as we'd both lived in the state at different points of our lives, loved NYC, and same-sex marriage had yet to be legalized in Georgia. It was a no-brainer.

The invitations were out, the RSVPs in, flights were booked, and the hotels reserved. We were ready, as were the twenty-five guests coming in from London, Atlanta, South Florida, etc. It was an electric time in our lives and we couldn't wait to share it with our loved ones. But six weeks before our wedding date, things took an extremely dark turn.

We were lying in bed watching TV, when Hannah reached over to grab something off of my end table. As she pulled her arm back it grazed the side of my left breast. She immediately looked at me with concern and said, "What is that?"

"Yeah, I felt it two days ago. I'm premenstrual, my breast tissue is thick. It'll go away once I get my period."

But it never did.

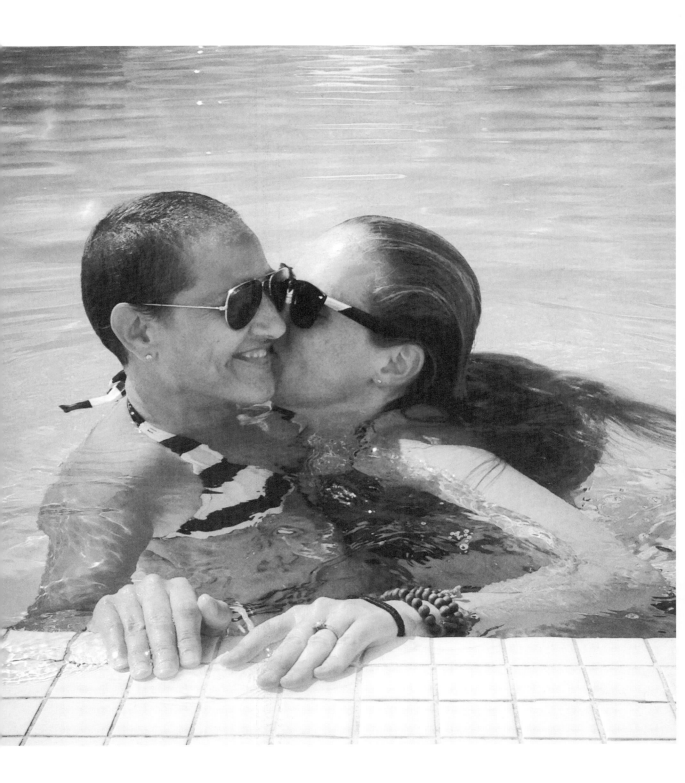

Six days later, Hannah and I anxiously awaited my biopsy results when we got the call that nightmares are made of. "I'm so sorry but you have breast cancer." I'll never forget the moment, listening to the nurse's instructions on "next steps," and mouthing to Hannah, "I have breast cancer." You know that dream where you're falling through space and the only thing that stops the fall is the sound of your alarm? That is what my diagnosis felt like, without an alarm.

To slow the fall, I had my army—caretakers, family, and friends. But stopping the fall was on me. Cancer has a funny way of indoctrinating unwilling participants and turning them into soldiers. I mean, I knew I was a tough broad, but had never battled like this before in my life. Whatever I needed to do to eradicate this disease, I was willing. I put on my helmet, put my head down, and pushed.

BARBARA GOTHARD

Fine Artist, Educator, Superintendent, and PhD

Born 1937 in Springfield, IL

It was 1983, I was forty-four years old, and my life was not working. Not for my mind, not for my spirit, and, most urgently, not for my body.

I'd had a recent hospital stay for a heart cauterization and at a follow-up appointment, my cardiologist told me in very stark terms that my expectation for a long life was at risk.

On top of balancing family, I was unhappy in my job and without spousal support to move into a different field. Although I was trying to further my education, working full-time, and studying in the midst of a highly pressurized home environment in which spousal expectations were rooted in then-traditional norms just wasn't working.

I was frustrated, overwhelmed, and unsatisfied. I was stuck and it was literally killing me. So when my doctor warned that if I didn't deal with my internalized anger, my prognosis would be grim, something clicked inside me.

Although I realized the kind of life-altering changes he was recommending couldn't be accomplished in twenty-four hours, I knew in that single moment—on my doctor's exam table—that I was ready to fight for myself. That was my "bolt of lightning."

I was the only one who could change the way I reacted to my circumstances, so I began to make my plans. First, I took the time to heal, physically and emotionally so that I'd be strong enough to make those necessary changes. And I did.

It was one of the most difficult eras of my life, but I know I wouldn't be here had I not seized my moment. I've been very fortunate to have had an extraordinary life after making the decision to fight for myself. And I've never looked back.

MICHELLE HURD

Actor and Activist

Born 1966 in New York, NY

It's a tricky thing to try to think of the first time I stood up for myself.

Being a biracial kid from back in the day came with its own obstacles.

Truthfully, I feel I've been fighting since the day I was born.

I was a difficult birth, coming out sideways and backward, swallowing a bunch of amniotic fluid. It was three days in the NICU before I could latch onto my mom, at which point my mother said I latched on with *such force*, she thought I'd NEVER let go.

Let go?

I've been fighting my whole life.

From walking down the street and having to correct people who thought my mom was my nanny.

To marching into the principal's office to defend the fact that I punched a boy in the face because he called me the n-word.

To accepting my dyslexia and then realizing what a gift it really is.

To answering questions from agents who wanted to know, for casting purposes, if I viewed myself as more Black or white, and having to explain that, if anything, I think of myself as a native New Yorker (a Greenwich Villager, to be exact) and that I'm an ACTOR and my job is to bring stories to life. ALL stories.

To standing up to Bill Cosby and saying NO.

The lesson that I have learned, from my very first moment of life, is to fight for the right to breathe.

To fight for the right to have my voice heard.

To fight for the right to be WHO I AM.

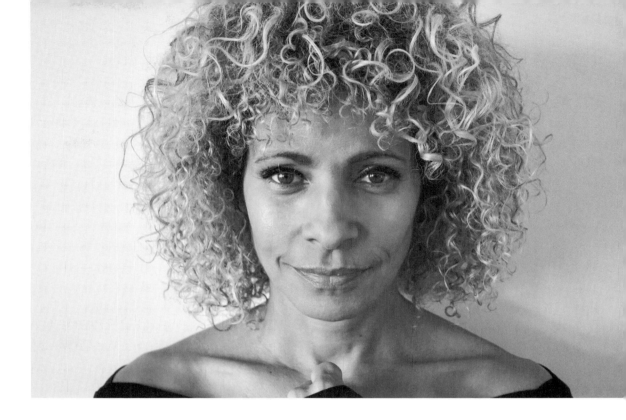

And fight for the right to say NO.

So many moments in my life, to this very day, have involved fighting for justice and, I gotta say, I've gotten very good at it.

I understand now that my journey in this lifetime is to FIGHT for those who are trying to find their voices and the strength to stand up and be WHO THEY ARE.

I believe all these battles, and learning to stick up for myself, have given me the ability and the tools to fight for others.

For that I will always be grateful.

LINDA PERRY

Producer and Songwriter

Born 1965 in Springfield, MA

Survival is all I know and honestly, the only thing my mother taught me.

I was born with kidney problems, and I was in and out of the hospital for the first five years of my life.

Unlike other kids my age, I would wet myself all the time at school because my bladder was weak. I had Monday through Friday school underwear so the kids made fun of me on a daily basis. I had no friend. I was pretty much a loner.

I had to fight for myself when my brothers would pin me down, beat me up, and call me dog face.

I'd fight back tears of disappointment because my father never saw me.

Unthinkable shame and guilt. . . . (To be continued.)

Dear Mother,

Being chased around with a hammer ready to crush my skull because I spilled milk on the floor?

Finding ways out of being tied to a railing because I was "too loud"?

Chained up because I played with the dog?

Beaten because I used the wrong towel? Manipulation, mental and emotional abuse? WTF?

But I loved you through it all.

At sixteen I got tired of fighting, so I took a bottle of pills. I was just in too much pain. What a loser. I remember waking up so disappointed in myself.

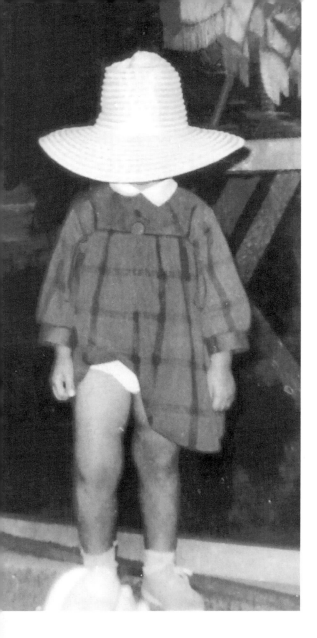

I fought through addiction, depression, not feeling good enough—ugly, fat, stupid, and gay. Blah blah blah!!

I took on an egotistical producer who fucked up a song that I knew was gonna make a difference in this world. Everyone considered me difficult. "Can't you just be a singer?" No, I fucking can't! So I took them all on by taking my band back into the studio and rerecording and producing the song myself. "What's Up" went on to be one of the biggest songs in the world.

The Megalodon of them all, ME! Oh, Linda, why are you so hard on yourself?

Now I'm fighting for other people. I'm simply trying to tell my story, share my truth to make a difference. I want to help girls realize how powerful they are. I fight for them, they, and us!

I am not a victim. I am a survivor!

MEG STALTER

Comedian and Actor

Born 1990 in Cleveland, OH

When I love myself in a more wild way than people want me to. When I double-text someone I like. When my brother tried to buy that car and the man was mean and it made me yell. That time I passed out when my sister gave birth to my favorite person and my mom told the doctor that she caught my head before I fell, but I told them that she was wrong, because she was. My mother is beautiful and warm and would never admit to not being able to catch one of us when we fall. I stood up for myself when I was honest and told my dad I was scared to pick just one thing to do in life and he said I didn't have to. He said we can live a bunch of different lives in one lifetime and that made me feel big. I stood up for myself when I was pressured to get that apartment by that woman who was being unkind and I was able to say no and walk away. I cried on a bench while eating a sandwich but found my dream

place within an hour. God, the universe, we are always given back what mean re-altors have stolen from us. I stick up for myself when I'm honest about how I feel. When I told him in the car that I liked him. When I sang her a song about how I liked her. When I sent her a painting after she said that I lived too far. Every time I told someone they hurt me. Every time I told someone I loved them most. That time I told that woman I couldn't work for her because of the way she talked about her housekeeper. When she interviewed me for the job she said, "So what's your plan, considering you won't be a famous comedian tomorrow." I don't want to be famous, I just want to make people feel good and alive. That's what sticking up for yourself is, going after what makes you feel alive. It's the greatest form of self-love and I'm absolutely relentless about it.

ACKNOWLEDGMENTS

To our incredible team at S&S, starting with our rock star publisher, Jen Bergstrom, and editor, Lauren Spiegel. Thank you to Mackenzie Hickey, Sydney Morris, Lisa Litwack, Davina Mock-Maniscalco, Sarah Wright, Brigid Black, Caroline Pallotta, Becca Kaplan, Jeff Wilson, Jennifer Weidman, Jen Long, Sally Marvin, Aimee Bell, Taylor Rondestvedt, and Rebecca Strobel.

To our agent, Meg Thompson, and her team, we are in awe of you every single day. Thank you for being on call for us 24/7 and for staying as passionate as we all are about this project, since day one.

To Jordan Gross and Karen Wacker-Slay, this book would not have happened without you both. Thank you for being always on, always available, and perfectly thorough. —Kristin, Kathy, Linda, Chely, and Lauren

I'm not quite sure why or how, but in the course of my lifetime I seem to bump into the most incredible women. I guess I've sort of come to believe that when two women are meant to know each other, the Universe allows or maybe even orchestrates a crossing of their paths. Thank you to all of the girls and women around the globe who trusted the Universe and trusted us with their powerful stories. —Chely Wright

Full-hearted thanks to my soul sister Kristin (I love you) and my huge admiration thanks to my fellow *My Moment* creators: Lauren, Chely, and Linda . . . (half a decade of you and me!). To all the contributors, thank you for your bravery, your

honesty, and your whimsy. Loved this entire process. Womxn's voices!!! —Kathy Najimy

Thank you to all the powerful, badass women in the world! —Linda Perry

Thank you to our village (you know who you are) for helping us get this incredible project completed and our boys picked up from school on time. To all the women and girls who have contributed to this book, thank you, thank you, thank you. It was an absolute pleasure working with each of you. To the rest of the women and girls out there, we see you and we are here for you. —Lauren Blitzer

I would like to acknowledge Chely, Lauren, Linda, and Kathy for being my partners on the journey of manifesting this incredible and important collection of stories. And I want to acknowledge my mom—Junie—who is the woman I most admire. —Kristin Chenoweth

PHOTO CREDITS

Note: Any photos not credited are courtesy of the contributor.

4	Chrissie Hynde	Photo by Helen Maybanks
7, 9	Clare Akumu	Photos by Joyce Apio (mother)
11	Samantha Brenner	Photo by Amy Simpson (girlfriend)
14	Miya Lao	Photo by Bailey Lao (sister)
17	Leelee Groome	Photo by Georgia Groome (daughter)
20, 22	Adrienne Warren	Photos by Dr. Andrea Warren (mother)
24	Carmen LoBue	Photo by Aury Krebs (partner)
28	Kelli O'Hara	Photo by Megan Osterhaus (best friend)
31	Brooke Baldwin	Photo courtesy of Brooke Baldwin
32	Aisha Tyler	Photo by Robert Adam Mayer
36	Maya Wiley	Photo courtesy of Maya Wiley
39	Michaela Pereira	Photo by Josh Kaplan
40	Joanna Gaines	Photo courtesy of Joanna Gaines
44	Ferial Pearson	Photo by Jessica Tworck (friend)
49	Anna Gifty Opoku-Agyeman	Photo by Fanta Isatou Gai
50	Orly Marley	Photo by Kristin Burns, courtesy of Tuff Gong Worldwide
55	Paola Ramos	Photo by Samantha Bloom (friend)
60	Hetal Jani	Photo courtesy of Jayashree Jani (mother)
63	Brandi Carlile	Photo by Hanna Hanseroth
64	Daisy Fuentes	Photo by Richard Marx
67	Kimberly Reed	Photo by Claire Jones (wife)
68	Melissa Peterman	Photo by Michelle Pedersen (friend)
73	Janelle Murren	Photo by Chely Wright (friend)
74	Marlo Thomas	Photo courtesy of Marlo Thomas
78	Kristin Chenoweth	Photo by Josh Bryant
82	Jenna Ushkowitz	Photo courtesy of Jenna Ushkowitz
84	Mandana Dayani	Photo by Tiffany Bensley (friend)
89	Jennifer Esposito	Photo by Jesper Vesterstroem
91	Shakina Nayfack	Photo by Eve Lindley (friend)
94	Shoshana Bean	Photo by Edin Espinosa (friend)
99	Emily Cain	Photo by Jeff Kirlin
100	Gloria Steinem	Photo by Sasha Turrentine
105	Debra Messing	Photo by Erica First (assistant)
109	Rosanna Arquette	Photo courtesy of Rosanna Arquette
112	Lynzy Lab	Photo by Pamela Lab (mother)
115	Kathy Najimy	Photo by Mona Moriya (assistant)
118	S. E. Cupp	Photo by Marlen Gonzalez

261	Sheryl Chinowth	Photo by Chinowth & Cohen
263	Cyndi Lauper	Photo by Helen Maybanks
264	Peppermint	Photo by Jay Knowles
267	Yasmeen Hassan	Photo courtesy of Yasmeen Hassan
268	Chelsea Handler	Photo by Faith-Ann Young
271	MJ Rodriguez	Photo by Audrey Rodriguez (mother)
272	Judy Mayfield	Photo by Meg Thompson (daughter)
277	Sharon Diamond	Photo by Idel Rivera
280	Havana Chapman-Edwards	Photo by Bethany Edwards (mother)
283	Becca Stevens	Photo by Sarah Stell
286	Meena Harris	Photo courtesy of Meena Harris
289	Shannon Juby	Photo courtesy of Shannon Juby
292	Amika George	Photo by Nisha George (mother)
297	Dorris Walker-Taylor	Photo by Jessica Phillips
300	Emily Saliers	Photo by Tristan Chapman (wife)
303	Jann Arden	Photo by Alkan Emin
304, 307	Celia Bell	Photos courtesy of Celia Bell Photography
309, 310	Stacey Topkin	Photos courtesy of Stacey Topkin and Alli Bennett (friend)
312, 313	Barbara Gothard	Photos courtesy of Barbara Gothard
315	Michelle Hurd	Photo courtesy of Michelle Hurd
317	Linda Perry	Photo by Aya Muto
319	Meg Stalter	Photo courtesy of Meg Stalter